IMAGES
of America

AROUND
WATERFORD

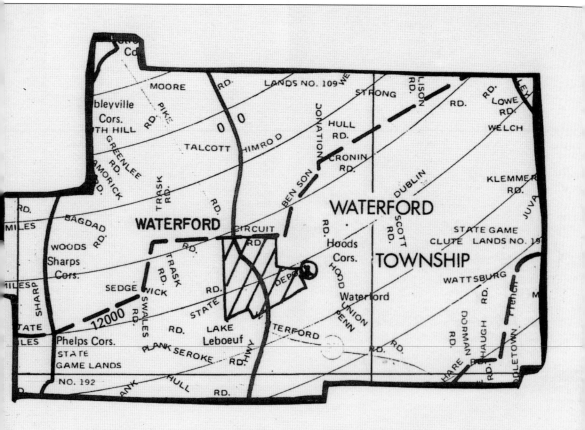

Waterford Township was established by the act for the organization of Erie County. The boundary lines are nearly the same as when the township was formed, the only exceptions being a small district annexed from Washington and another from Summit. The latter "handle" in the northwest was attached to Waterford through the exertion of Capt. Martin Strong, who wished to close his life in the township of his original residence. (Courtesy of Fort LeBoeuf Historical Society.)

ON THE COVER: Believed to be the only statue of George Washington wearing a British uniform, this is what he may have looked like as a major in the pre-revolutionary Virginia militia when he visited Fort LeBoeuf. He came to tell the French this was British territory and they had to leave. When they did not, this was the spark that ignited the French and Indian War. The statue, erected in 1922, has long been one of the most significant points of interest in the Waterford area. (Courtesy of Bill Joslin.)

IMAGES
of America

AROUND
WATERFORD

Rosalee B. Holzer, Dorris A. Proctor,
and Lisa Grygier for the
Fort LeBoeuf Historical Society

ARCADIA
PUBLISHING

Copyright © 2012 by Rosalee B. Holzer, Dorris A. Proctor, and Lisa Grygier for the Fort
 LeBoeuf Historical Society
ISBN 978-0-7385-7697-8

Published by Arcadia Publishing
Charleston, South Carolina

Printed in the United States of America

Library of Congress Control Number: 2011943284

For all general information, please contact Arcadia Publishing:
Telephone 843-853-2070
Fax 843-853-0044
E-mail sales@arcadiapublishing.com
For customer service and orders:
Toll-Free 1-888-313-2665

Visit us on the Internet at www.arcadiapublishing.com

CONTENTS

ACKNOWLEDGMENTS

We would like to thank the many members of the Fort LeBoeuf Historical Society and their families and friends for their time and effort in helping to make this book possible. The experience brought back many fond memories as we shared stories about the pictures and the people that make up our wonderful community. Unless otherwise noted, all images appear courtesy of the Fort LeBoeuf Historical Society.

We also wish to thank our editors at Arcadia Publishing: Hilary Zusman, who started us out on this creative endeavor; Erin Vosgien, who took over and steered us onto the right path; Darcy Mahan, for her expert guidance, encouragement, and patience as we traversed through the pages of history; and Abby Henry, who was with us until the end.

It was not easy to condense 200 years of development into the pages of this book. Important names, faces, and events will undoubtedly be left out, and for this we apologize.

INTRODUCTION

Tucked into the extreme northwestern corner of Pennsylvania, in Erie County, is Waterford Township and borough. The town is known for its quaint shops, restaurants, and deep sense of pride for its rich historical past. Ask any resident of Waterford what makes the town so special, and they will tell you Waterford is one town that can truly say George Washington slept here.

The first white men to enter the region were the French Jesuit missionaries in the early 1600s. The Indians they found were called the Eriez, or "Nation of the Cat." It is said their clothing was made from the skin of raccoons, which the French thought were a kind of feline. By the time the French built Fort LeBoeuf in 1753, trade with the Indians was well established.

Most of the founding families of Waterford have disappeared, either through marriage, relocation, or death. The Judsons, Kings, Strongs, Vincents, and Brothertons, who were so influential in shaping the once-rough frontier landscape into the rural community it is today, are gone; the legacy they left behind, however, lives on in stories passed through the generations. One prominent entrepreneur was Reuben Sharpe. Reuben and Louisa Sharpe were from North Walsh, England, and after coming to the United States, they settled in Vermont. In 1816, they moved to Waterford Township and bought a farm in the area now known as Sharpe's Corners. In 1819, after the death of their son John, they established Sharpe cemetery. The Sharpe family was also instrumental in the establishment of the schoolhouse in 1836 and the Methodist Episcopal Church in 1838. The cheese factory they built in the 1870s continued to operate until 1914.

War is hard on every community, and Waterford has lost its share of citizens during every war since the Revolutionary War and continuing through today's conflicts. In the spring of 1941, the junior and senior classes of the Waterford Joint High School were attending their senior class banquet at the Waterford Hotel. The event abruptly halted when the FBI arrived, taking the owner and manager of the hotel into custody on suspicion of spying on the US government. The bureau had received an anonymous tip that there was a shortwave radio in the basement of the establishment, which may have been used to transmit information to the Germans. Despite this, no charges were ever brought against the individuals. It was in December 1941, and approximately eight months later, the United States officially entered World War II after the bombing of Pearl Harbor by the Japanese.

As highways improved, travel by car became the favorite mode of transport. The Perry Highway was paved in 1917, and Erie was then only about half an hour away. Large factories and other businesses in Erie provided employment for many. The area around Waterford became perhaps a bit quieter and a little less self-contained, but it still retained its rural charm. It is still a great place to visit and to call home.

The Fort LeBoeuf Historical Society has instituted seasonal celebrations throughout the year, including Colonial Christmas, which is held in early December to kick off the Christmas season. Heritage Days in July has grown into a community-wide celebration with reenactors, food, parades, craft shows, and entertainment, all planned to showcase the town's past. Recent government

cutbacks have resulted in loss of funding for the Judson House and Washington Park, and presently the Fort LeBoeuf Historical Society is spearheading an effort to raise funds to purchase both of them to ensure that the historical legacy of the community will never be lost.

Around Waterford is by no means a complete history of the area, but rather a thumbnail sketch of the community to highlight what has made the town what it is today. Included is material only up until the 1950s, leaving the rest to be completed by future generations.

One

THREE FORTS AT LEBOEUF

By the early 1750s, the French and the British were in a race to control the rich lands south of the Great Lakes. To head off British encroachment, the French built a chain of forts to connect the Great Lakes and the Mississippi River with their holdings in Montreal and New Orleans. In 1753, they established Fort Presque Isle on the shores of Lake Erie and Fort LeBoeuf 14 miles south. From LeBoeuf, they could travel by boat and canoe to the Allegheny River, which carried them on to the Mississippi.

When information reached Williamsburg, Virginia, about the French army's activities, Lt. Gov. Robert Dinwiddie realized war was inevitable. Despite this, he felt that a last attempt should be made to ask them to withdraw. He sent a young George Washington with a letter requesting the French to leave. Washington arrived at Fort LeBoeuf, and though treated courteously, he was told the French were not leaving. This was the spark that ignited the French and Indian War. In 1759, the French were finally forced to abandon their forts and the British, under the command of Major Rogers, took control.

The following year, the British built a small fort at LeBoeuf, but in 1763, Indians burned the fort and forced the soldiers to flee. The Indian Nations subsequently controlled the area for nearly 30 years. In 1794, an American fort was built by Maj. Ebenezer Denny to protect the surveyors and settlers who were coming into the area. It had various uses until it burned in the 1860s.

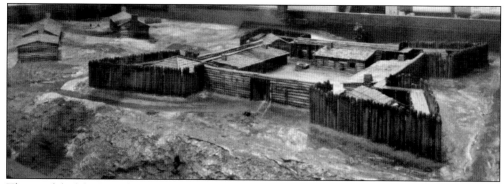

This model of the French Fort LeBoeuf is in the Judson House Museum. It was constructed in the 1930s by the Museum Extension Project, which was sponsored by the Works Progress Administration (WPA), a federal program intended to provide work for the unemployed. George Washington's journal of his trip to the French fort provided the information from which it was built.

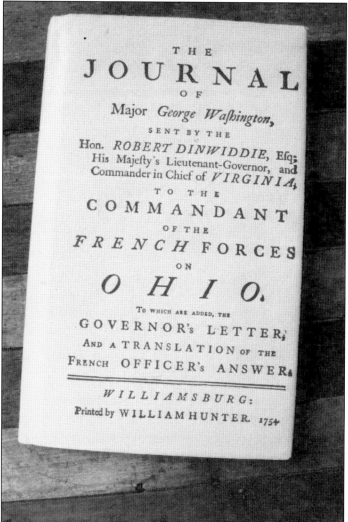

George Washington kept a journal of his trip to Fort LeBoeuf. In it, he carefully described what the French obviously seemed to be planning, which left little doubt that war was inevitable. His account was published immediately, and it was widely read in both the colonies and in England. Washington's name soon became known on both sides of the Atlantic. His journal was reprinted for publication in Williamsburg, Virginia.

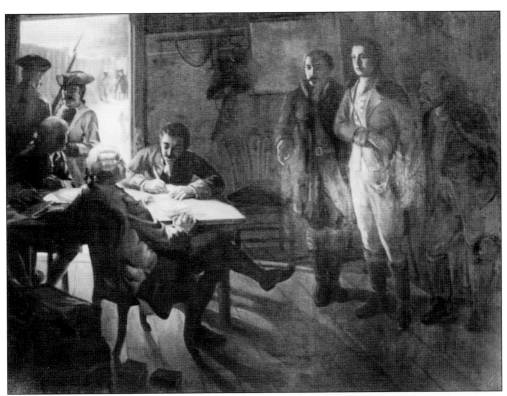

This oil painting, titled *Washington at LeBoeuf*, is located in the Judson House Museum. It depicts Washington presenting the message from Governor Dinwiddie to Jacques Legarduer de Saint-Pierre, the French commander. The original, painted by A.G. Heston in 1867, hung in the Union League Club in Philadelphia. Helen Lowden Evans painted this replica in 1952. Because the ULC was a men's-only club, Helen needed special permission to enter the premises.

In 1794, Governor Mifflin sent Capt. Ebenezer Denny, a commander of the American troops, to protect the settlers and surveyors. Denny built a third fort on the site of LeBoeuf and managed to settle problems with the Indians without resorting to bloodshed. Andrew Ellicott, who was in charge of the surveyors, reported to Governor Mifflin that "Captain Denny merits highest commendation for his work."

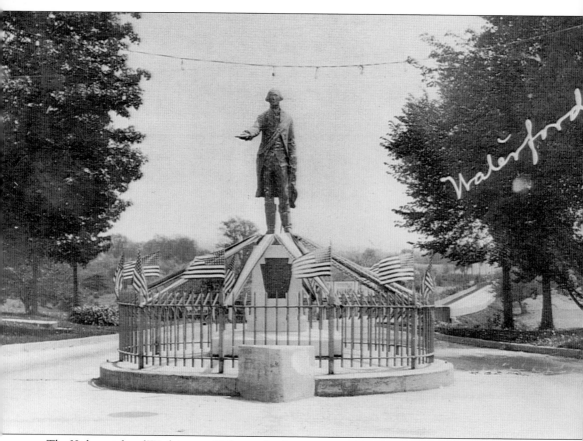

The Kirkpatricks of Washington, DC, cast this bronze statue of George Washington. It was erected in the middle of the main highway, south of the Eagle Hotel at the site of the original Fort LeBoeuf, on August 30, 1922. The statue depicts Washington as a major of the Virginia militia delivering a message from Virginia's Governor Dinwiddie to the French telling them to withdraw from the area, as it was claimed to be British territory. The statue became a traffic hazard and was moved to a nearby park in 1948. In the early 2000s, members of the Erie Masonic Lodge, along with the Pennsylvania Historical and Museum Commission and local citizens, moved the statue nearer to the highway. They improved the landscaping and added flags representing the three forts of France, Britain, and America. George Washington Memorial Park is the pride of the Waterford community and is a main attraction for citizens and travelers alike.

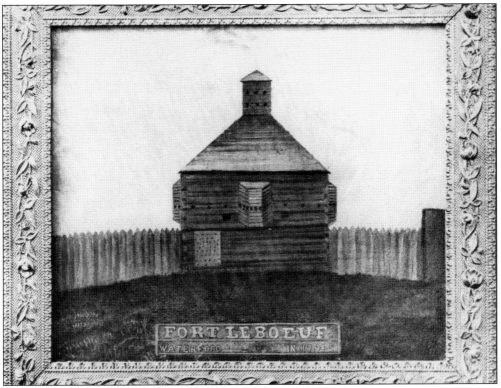

This postcard depicts a blockhouse that may have been part of the fortifications built by Captain Denny. Some accounts, though, say it was built three years later by Lt. Charles Martin, who commanded the fort and then permanently settled in Waterford. In later years, it was used as a storehouse, a prison, a private home, and a hotel until it burned in 1868.

In August 1932, the Daughters of the American Colonists and the Daughters of the American Revolution rededicated the site of the 1753 French Fort LeBoeuf in honor of George Washington's 200th birthday. The site, next to the Eagle Hotel, has since been altered. It is now George Washington Memorial Park and is home to the George Washington statue.

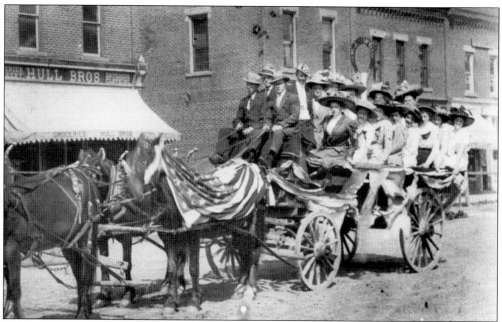

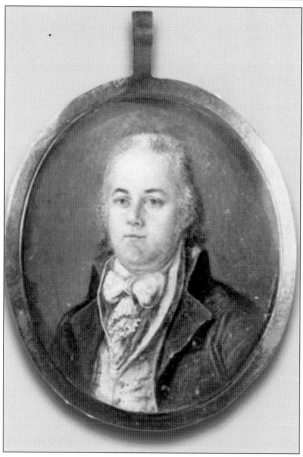

The rededication of the site of the fort and the George Washington statue included many festivities, including a parade. The gaily-costumed passengers in the wagon drawn by four horses may have been members of the Daughters of the American Revolution, one of the sponsors of the event. Pictured behind them is the Hull Brothers Store, which was located at the corner of Main Street and Second Alley. (Courtesy of Anita Palmer.)

In 1794, Andrew Ellicott was one of the surveyors commissioned by Governor Mifflin of Pennsylvania to establish a road from Reading to Presque Isle. It was his idea to have "reservations" at strategic points along the road and partition them into lots for settlement. These lots were offered for sale in Pittsburgh, Philadelphia, and Carlisle. Ellicott's "reservations" became the towns of Warren, Franklin, Erie, and Waterford.

Two

PIONEERS AND
NOTABLE CITIZENS

Once a peace agreement with the Indian Nations was finally achieved, surveyors began plotting out the new territory. They laid out streets and alleys, public areas, and lots for schools and churches. The outlying land around the town was also surveyed. Some parcels were given to Revolutionary War veterans as payment for their services, and the rest were offered for sale. When word went out that property was available in northwestern Pennsylvania, it sold rapidly as settlers came flooding in.

Among Waterford's early settlers were those who had the energy and knowledge to embark on enterprises to benefit the community and its people. They were hardy, adventurous, and brave, and it was because of their superior intelligence and determination that the town progressed so quickly.

Some of the first to settle here were Lt. Charles Martin, commander of the troops in 1795, and James Naylor, one of the land commissioners. Martin opened the first tavern in 1797 and later opened a hotel. Naylor established the first store. Other entrepreneurs, such as Capt. Martin Strong, Amos Judson, Thomas King, John Lytle, and John Vincent, soon followed. The birth of Waterford had begun.

During the latter part of the 19th and the early 20th centuries, other figures arose to become notable in local, regional, and even national history. Their diverse fields of endeavor have included farming, religion, education, banking, politics, and the military. Brotherton, Hovis, Hunt, McCray, Porter, Wishart, Himrod, Davis, Ensworth, and Vincent are a few of the names that have been, and are still, prominent in the community.

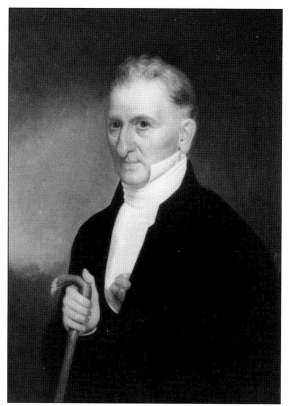

Amos Judson, one of Waterford's most influential citizens, arrived from Connecticut in 1795. Although a cabinetmaker by trade, he soon found his niche as a businessman and entrepreneur. In 1808, he was managing Holmes and Herriot's store. In 1815, he purchased their stock and opened his own store across from his residence, taking Samuel Hutchins as a partner. In 1826, they constructed the three-story brick building on the corner of West First and Main Streets. In 1847, their partnership was dissolved, and Amos took two nephews as partners. A generous, civic-minded individual, he was burgess for years and was a founder of Saint Peter's Episcopal Church. In 1810, he built the first portion of his house on East First and Main Streets in old New England style with a stable attached. In 1820, he added a two-story section in the Greek Revival style.

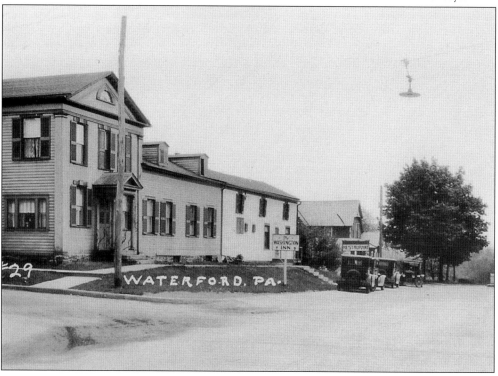

WATERFORD, PA.

Thomas King came to Waterford in 1795 with his father, Capt. Robert King, an officer in the Revolutionary War. For his service, Captain King was awarded 400 acres of land south of Waterford, near the junction of French and LeBoeuf Creeks. He called his place King's Garden. Thomas King first had an establishment at West First and Walnut Streets named the Yellow Tavern, which burned in 1825. Not deterred by this disaster, he planned and built an imposing stone structure called the Eagle Hotel, which still stands at the corner of First and Main Streets. It opened in 1827 and was soon famous for its fine accommodations. The area was still a raw frontier, and this elegant building was an imposing sight, especially since there were few stone structures in Western Pennsylvania. In 1842, at the age of 60, King sold the hotel to Amos Judson and moved to Erie.

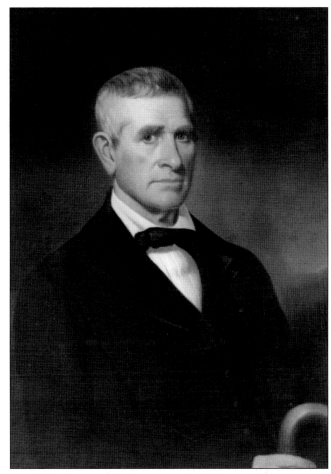

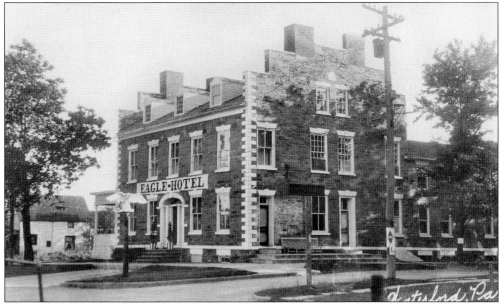

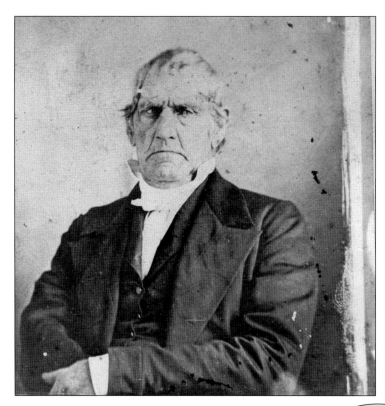

The Honorable John Vincent walked the entire distance from Pittsburgh to Waterford in 1797. He had a limited education, but his natural intellect, common sense, and integrity helped him procure his appointment as justice of the peace of Waterford in 1803. He was appointed associate judge of Erie County in 1805, a position he held for 40 years.

The Honorable William Benson was born in Waterford on April 5, 1818, and received his education at the Waterford Academy. At 17, he taught in several district schools, including the academy. In 1850, he was elected justice of the peace, serving until 1866. He was then elected as the last associate judge of Erie County, serving until 1881. He was a county surveyor from 1854 until 1863. In 1861, he partnered with Chester West in the banking firm of Benson and West.

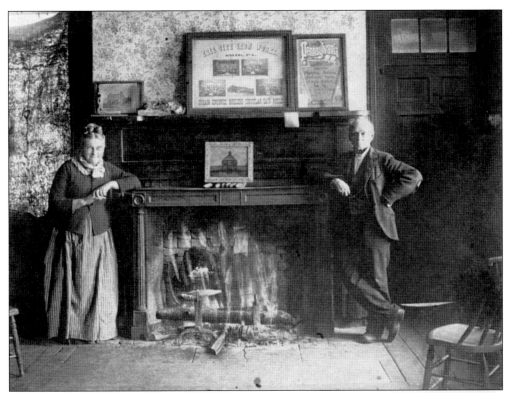

Pierpont E. Judson came to Waterford in 1823 and began working for his uncle Amos Judson. He also worked at the Waterford Hotel until he was able to open the old fort building as a hotel. The hotel was destroyed by fire in 1868, and in 1870, he acquired the Eagle Hotel. He sold the Eagle Hotel in 1872 but repurchased it in 1879. The woman in the photograph is unidentified, but she may have been a longtime cook at the hotel.

Charles Shaw was a prominent member of the Waterford community. He served as postmaster from 1935 until 1953, when the post office was located in the Masonic building on the southeast corner of Main and Second Streets, and after it was moved to the west side of Main Street between West Second Street and Second Alley. In 1922, he reopened the LeBoeuf Theater with Millard Wilder on West Main Street between Second Alley and West First Street.

A Mr. Talcott of New York purchased the Becker farm in July 1890 for $4,000. The property, which contained 110 acres, was located two miles north of Waterford on Talcott Road. Talcott is remembered as the man who married Effie True, a local schoolteacher. The Talcott family eventually sold the property, and it became a strawberry farm.

Effie True was the daughter of John True, a farmer. His farm was located on what is now Sharpe Road, south of Old State Road. Effie was a popular schoolteacher in her day. She taught in several Waterford Township one-room schoolhouses, including Strong School on Route 19 and Sedgwick School on Sedgwick Road. She also taught in Waterford Borough Elementary School.

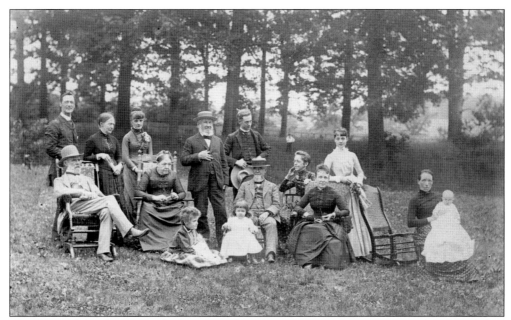

The Reynolds family of Waterford is pictured in 1888 enjoying a summer get-together. From left to right are (seated on the ground) children Margaret and Clara; (seated) uncle and aunt Reynolds, uncle Davie, aunt Kate, aunt Fannie, and an unidentified woman, who is holding baby Frances; (standing) Mr. and Mrs. Reynolds, Kate, uncle John, Ned, and Bess.

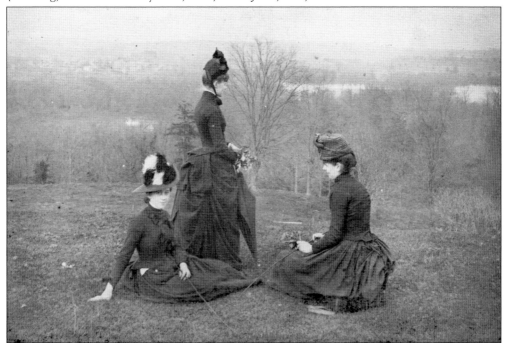

From left to right, Minnie Barton, Katherine Wishart, and Emma Himrod, three lovely young ladies from well-known Waterford families, show off their spring finery and fashionable hats. This late-1880s photograph was taken from the top of Simpson's Hill just off Old State Road. Lake LeBoeuf is visible in the valley below them.

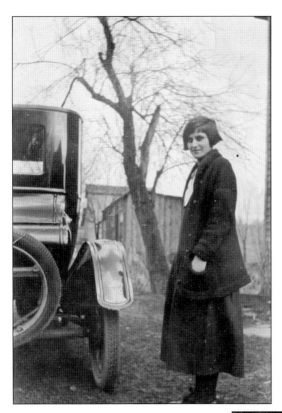

Dorothy Davis McCall admires her new car in 1926. Dorothy was a lifelong member of the community, including the First (Park) Presbyterian Church. She was a schoolteacher and taught in the one-room country schoolhouses in Waterford and Mill Village. She was also very active in the Daughters of the American Revolution and the Waterford Garden Club.

Cynthia Stranahan Brotherton Ensworth grew up in LeBoeuf Township, where the Stranahans settled. She married Robert Lyn Brotherton of Waterford. In 1923, she helped organize the Daughters of American Colonists and in 1925 the Daughters of American Revolution. She served as regent of both. She was a registered genealogist and researched over 1,700 families of early settlers. She was widowed but later married Arthur Ensworth, a banker.

Harry Merritt was a lifelong resident of Waterford, born September 28, 1876. He married Bertha Davis, and they had two sons, Milton and Waldo. Harry was very active in community affairs as justice of the peace, tax collector, and burgess. He also served on the cemetery association, the school board, fair board, the Methodist Church board, and was a member of Waterford's Masonic Order. He was owner and publisher of the *Waterford Leader*.

Shirley Merritt Barton was the only sister of Harry Merritt and lived in Waterford her entire life. She married Lloyd Barton, MD. Their residence, which was also the doctor's office, was in the house immediately south of the Eagle Hotel. It is still standing and has been extensively remodeled by its present owners.

From left to right, Rollo McCray, Charles S. Shaw, and Harry L. Merritt are pictured around 1900 as fashionable young men clowning for the camera. All three became very influential members of the community. McCray became Erie County treasurer, Shaw became postmaster of Waterford, and Merritt was owner and publisher of the Waterford newspaper as well as justice of the peace.

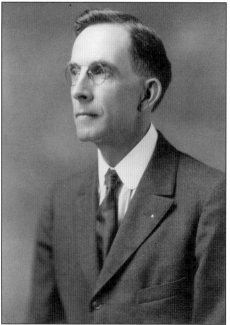

Rollo McCray was born in 1876 in Spring Creek, Pennsylvania. In 1883, his family moved to Waterford, where he graduated from the Waterford Academy. In 1900, he joined his half brother Marion Patten in his general store. In 1906, Rollo was elected burgess of Waterford. He was active in every civil and fraternal organization and was also Erie County treasurer from 1940 through 1944.

Raleigh Barnes (1884–1954) was a native of Waterford who became a dentist. For a time, he was the only dentist to have a practice in Waterford. His office was upstairs over what is now Al's Appliance. His wife, Evangeline Henry Barnes (1884–1971), grew up in the elaborate residence that is now the Waterford Hotel. During her wedding to Dr. Barnes, which was held in her home, the train of her gown covered the staircase from top to bottom when she descended. It is said to have been one of the most beautiful weddings ever held in the community. Evangeline Barnes was very active in the Daughters of the American Revolution and several other organizations.

Annice Gertrude Ensworth McCray was the daughter of Frank and Mary Roberts Ensworth, who were prominent members of the Waterford community. Annice attended Waterford Academy and Saint Peter's Episcopal Church. She was very active in many organizations, including the social club she founded in 1900, the JAG (Just All Girls). She married Rollo McCray, and they had a daughter, Mary Annice, who became a librarian in the Erie County Library System.

Marjorie McKay, daughter of Paul and Belle Green McKay, is shown in this 1923 photograph on the day of her wedding to George Richardson in St. Peter's Episcopal Church. Her grandfather John Wood had come from England in 1825 to become the first headmaster of the Waterford Academy. McKay Hall in St. Peter's Church and the McKay Richardson Room at the Eagle Hotel are both dedicated to her.

Three

INNS, HOTELS, AND ARCHITECTURE

When the first settlers came to this area, there was a need for public houses or hotels until they were able to establish their own homes. Inns and hotels played an important role in the life of Waterford from the beginning. Some of these places were small, temporary, and primitive, but others were built that were more substantial.

Capt. Charles Martin built the first hotel on the corner of Water and Cherry Streets in 1795. Over the years, there have been as many as 14 inns and hotels in and around Waterford. Images of many of these establishments, including the Yellow Tavern at First and Walnut Streets, Cook's Hotel on West Fourth Street, the Union Hotel at the corner of West Main Street and South Park Row, and the LeBoeuf Hotel on Main Street, have not survived the ages. Just south of the Eagle Hotel was a blockhouse, part of the old Fort LeBoeuf, which was converted into a hotel. Pres. Zachary Taylor was a guest there on his visit to the area. The Phelps Hotel on Main Street near West Second Street, the Colt Hotel at East High Street and Second Alley, Strong's Hotel north of town on the west side of Route 19 at Sharp Road, and Gould's Lodge south of town in LeBoeuf Gardens are others in need of mention.

The Park House and all of the small hotels are gone now, but the Waterford Hotel and the Eagle Hotel still remain and feature fine restaurants. The Waterford Hotel is privately owned, but the Eagle Hotel belongs to the Fort LeBoeuf Historical Society. Recent renovations to both of these handsome buildings make a visit worthwhile. In addition to these two hotels, many older houses with interesting architectural features are still scattered throughout the community.

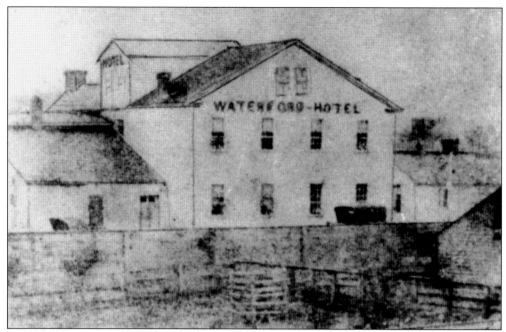

George W. Reed built the original Waterford Hotel on East First Street in 1810, but tragedy struck when it burned only a few years later. It was rebuilt in time for the arrival of General Lafayette and his party in June 1825. They were entertained there overnight before being escorted to Erie, where a grand celebration was held in the general's honor.

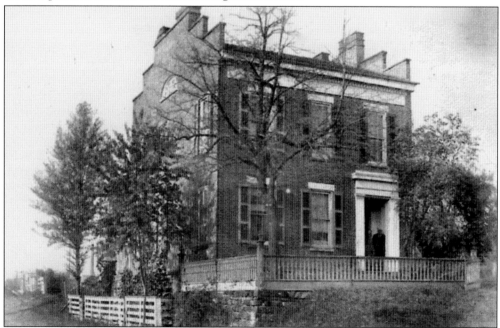

The house built for William and Clarissa King Judson in the mid-1800s is located at 104 Walnut Street. Charles and Alice Judson Himrod later inherited the home, and in the early 1900s, Alice Himrod's nephew George Lamberton inherited it. W. Levant and Gladys Porter Alcorn purchased it in 1945, and it remains in the Alcorn family today.

Robert Brotherton, an early settler, built the Brotherton Inn on the northeast corner of First and Cherry Streets. It was a very popular public house. Brotherton owned the inn for two years. It was taken over by Hannah Pym from 1815 until 1817. She had entertainment and was said to be one of Erie County's most colorful women. The inn was later moved up the block, one lot north on Cherry Street.

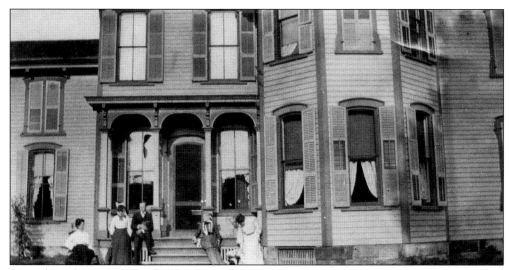

Samuel Brotherton, a Waterford banker and the only surviving son of Robert Brotherton, wanted the corner for his house, so Robert moved the tavern to the back lot facing Cherry Street. Marvin & Company built the house on East First and Cherry Streets in 1864. Samuel passed away in 1886, willing the house to his wife, Mary Marvin Brotherton, and their three sons. Cynthia Stranhan Brotherton inherited both houses, moving into the tavern house and selling Samuel's. (Courtesy of Anita Palmer.)

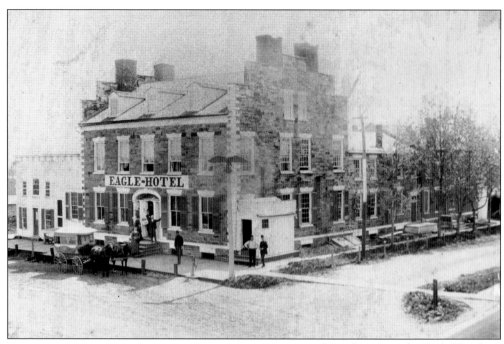

Over the years, the Eagle Hotel has been restored to a place of charm and elegance and has been placed in the National Register of Historic Places. The first floor is leased to a restaurant that serves old-fashioned, home-style cooking. The second floor, which is still undergoing restoration, is decorated in period style and holds part of the Fort LeBoeuf Historical Society's collection of artifacts. The third floor features a ballroom and several small adjoining rooms.

Stanley Craker was the grandson of P.E. Judson. He became the owner of the Eagle Hotel in 1899 and ran it for 45 years. His nephew Carl Guyer joined the business, eventually becoming the succeeding owner. The hotel catered to commercial men, and during the "Big Band" era, Guy Lombardo and Stan Kenton were guests of the hotel. In 1973, Carl sold out to two gentlemen from Erie. In 1977, the Fort LeBoeuf Historical Society purchased it.

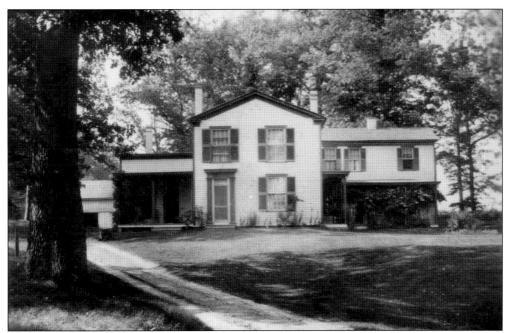

The main part of the house on East Fifth Street was built for Rev. Tobias Harper Michell, MD, when he was rector of Saint Peter's Episcopal Church between 1839 and 1849. David and Abigail Patten Himrod purchased it in the early 1850s and added the two wings. Tracy Himrod later acquired the property and lived there until his wife died. David Musser is the current owner.

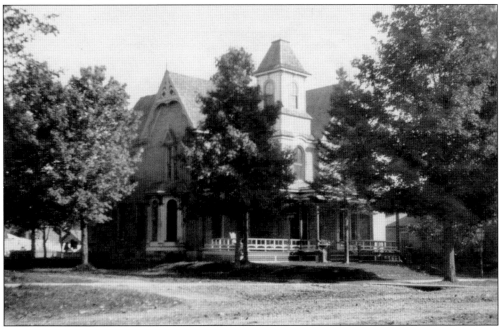

The stately house on the southeast corner of South Park Row and Main Street was built as a private residence. It later became an inn and operated under several different names, including the Blystone House, the Camp Inn, the Green Goose Inn, the Lincoln Hotel, and the Waterford Hotel, which still operates as a tavern and restaurant.

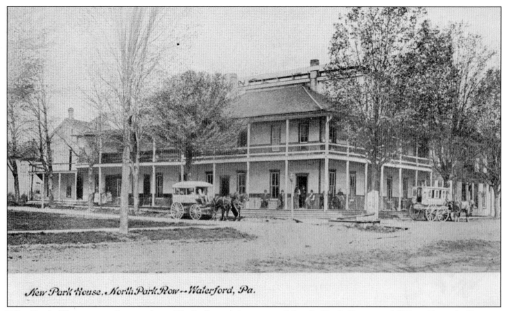

New Park House, North Park Row — Waterford, Pa.

The Park House was located on High Street between North Park Row and West Fourth Street. It was built around 1880 by John L. Cook and known for its fine dining room and the service of its livery. Before constructing the Park House, Cook had been proprietor of Cook's Hotel, which is where the American Legion Club is now located. He also owned the Eagle Hotel from 1857 until 1862. An expert carpenter and joiner, Cook left town for several years to work in the construction industry. Eventually, he returned to Waterford to construct the Park House and several other buildings. As the need for hotels in the area waned, the structure was torn down and other buildings were erected. One of the buildings that replaced it houses the Stancliff Hose Company, Waterford's fire department.

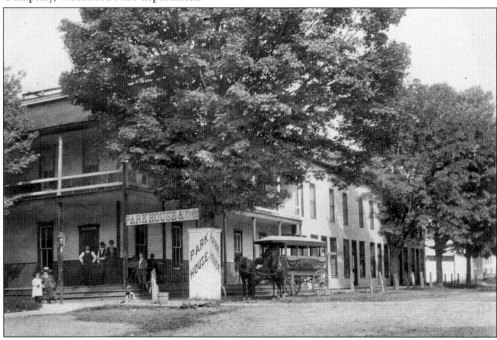

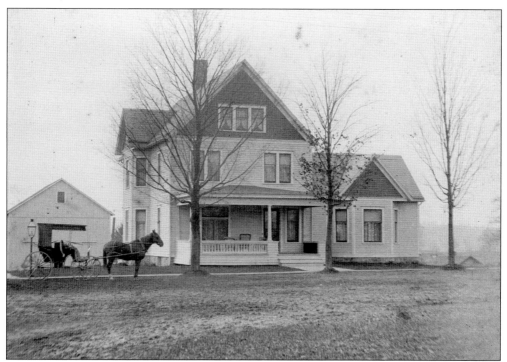

The Wishart House, located on Main Street between Sixth Alley and Seventh Street, was built in the 1870s. A. Park Shaw originally owned it, but the Reverend and Mrs. Marcus Wishart later purchased it. After their death, their daughters Katherine R. Wishart and Elizabeth Wishart Saeger continued to live there.

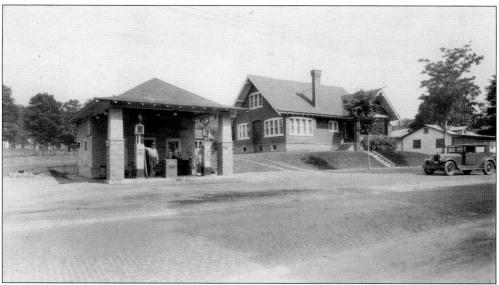

Kaspar "Cap" Maurer built the brick house and gas station on Main Street between Sixth and Seventh Streets in the late 1920s. "Cap" had been a successful businessman for years in Waterford and was proprietor of the Park House Hotel. He lived in the house until he moved in with relatives due to poor health. Marvin and Janet Cross are the present owners of the house. The gas station has had several owners offering varying services.

Ira Hamilton, son of John Hamilton, was an early settler of Waterford. His home was located on the corner of East First and Chestnut Streets. Since 1883, the house has been renovated many times. Ira Hamilton married Amy Augusta Moore, and they are the parents of Helen Hamilton, who married E.L. Heard of Waterford.

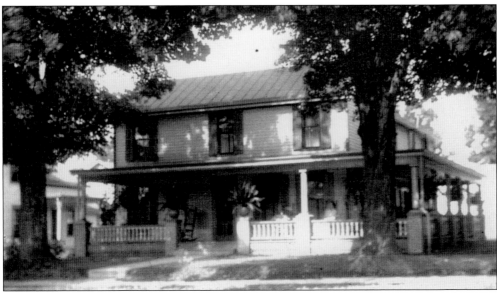

F.E. Mallory built the house on Walnut Street next to the old home of Joseph L. McKay between Second and Third Streets in Waterford. Will Camp later owned it. Other notable families who owned the Mallory house were George Coffin, Roscoe Mitchell, F. Free, and Osborn Moore. The Gordon Marsh family are the current owners.

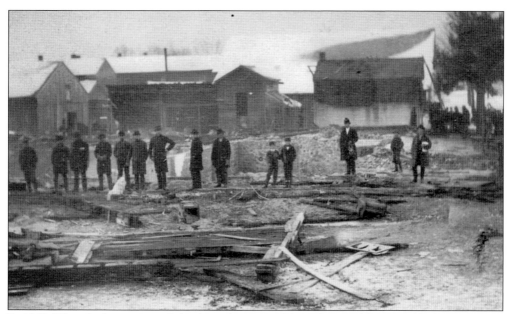

In 1865, Waterford experienced the first of a series of fires that would eventually destroy all but one of the original frame buildings. Subsequent fires occurred in 1873, 1881, and 1883, and a major fire in 1895 destroyed the majority of buildings along the west side of the street. Following the fire of 1895, the town council passed an ordinance prohibiting the construction of frame buildings on High Street. By August 1895, buildings had been reconstructed using brick instead of wood. In the above photograph, fire destroyed the businesses in the block between West Second Street and the park. The photograph below shows damage from a later fire. The grocery store of Gillette and Phelps and the Phelps Hotel were among other businesses that sustained heavy damage. The post office was located on the corner and also suffered severe smoke damage.

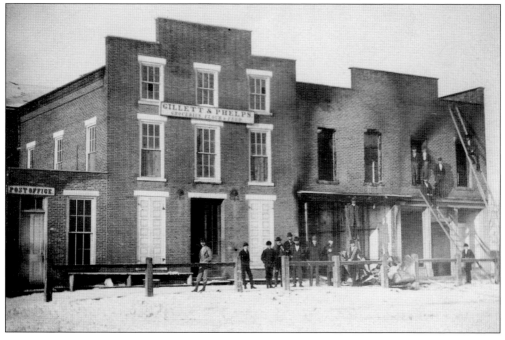

The original house of Joseph McKay, son of Capt. John McKay, is located on Walnut Street between West Second and West Third Streets. In the 1950s, it was sold and converted into Marsh Sales and Service Appliance Store. It is now an apartment complex owned by Robert and Cynthia Marsh Salchak.

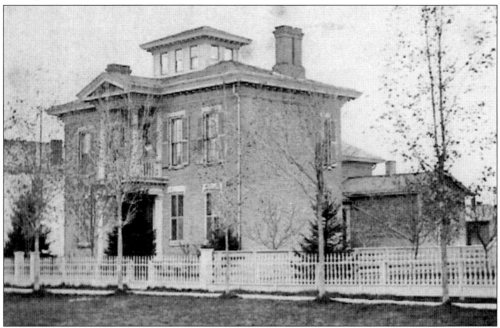

The stately manor located on West Third Street was once the home of the F.F. Farrar family. Carl Perkins later purchased the house and lived there with his family. Eleanor Perkins, his daughter, worked for the post office for many years. Some of its later owners included Ollie Brown and Robert and Patricia Abraham. Attorneys Jeffrey and Rebecca Herman now own the property.

Four

COMMERCE AND AGRICULTURE

The business district on High Street in 1860 was lined with two- and three-story frame commercial buildings. Everything from dry goods and clothing to hardware, paints, and pharmaceuticals was available in Waterford.

One of the great industries of the late-18th and early-19th centuries was the salt trade. The salt was mined in New York, shipped to Erie, hauled overland to Waterford by oxen, and shipped in flatboats to Pittsburgh. Salt was a prized article of commerce. Many other commodities were priced at so many pounds or barrels of salts. Warehouses were located near the inlet of Lake LeBoeuf, where the salt would be unloaded and stored to await final delivery. Salt wells were discovered near Pittsburgh in 1813, and by 1819, the business of transporting salt through Waterford had completely ended. Waterford continued to be regarded as an important military location, however, when the headquarters for northwestern Pennsylvania was established there at the beginning of the Civil War in 1861.

By 1900, employment opportunities and population had declined. The community and surrounding township were stabilized as an agricultural area, with potato farming, dairy, and cattle production growing in importance. After railroads were built, it was relatively easy to ship agricultural products to nearby cities. Corn, cabbage, grain, milk, cheese, and meat became important commodities. Over the years, several small businesses processing agricultural products have come and gone, but agriculture still plays a major role in Waterford's economy.

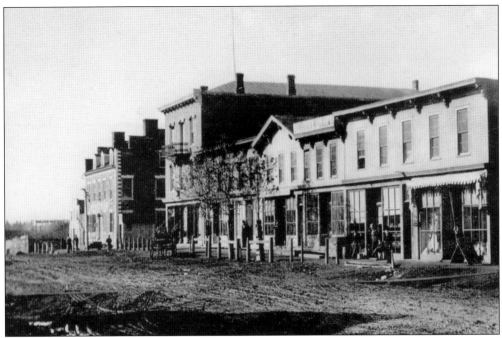

Downtown Waterford looked much different in the 1860s. The large building to the left is the Eagle Hotel. Partners Samuel Hutchins and Amos Judson constructed the next building in 1831 as a general store. The partnership later dissolved, and Judson or his nephews were running it at the time of this photograph. The rest of the buildings burned in 1865 and were subsequently rebuilt using brick.

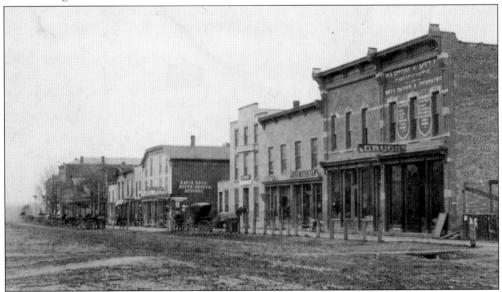

This photograph was taken from South Park Row. The Union Hotel had been on the corner next to the drugstore but had to be demolished after a fire in 1873. The Independent Order of Odd Fellows Lodge building was constructed on the site. Their meeting room was upstairs, and the pool hall and store business was conducted downstairs. The building is now home to the Waterford Pharmacy. Waterford's downtown area was rejuvenated when it was rebuilt after the fire of 1895.

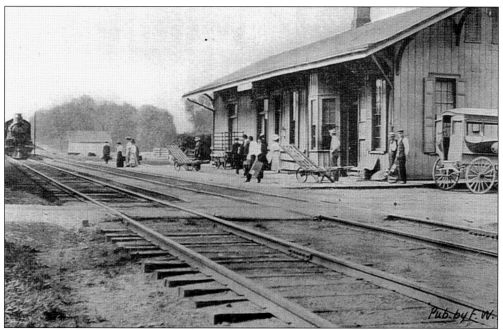

The Waterford Station, commonly called the "depot," was erected in the mid-1850s to service the Philadelphia & Erie Railroad. It was located two miles east of Waterford because residents did not want the railroad running through town. A telegraph office was located in the building. Other businesses soon sprang up, including a hotel-grocery store, a cider mill, the Sulky Rake Factory, the Merrell Soule Milk Plant, an icehouse, a school, and a Catholic church.

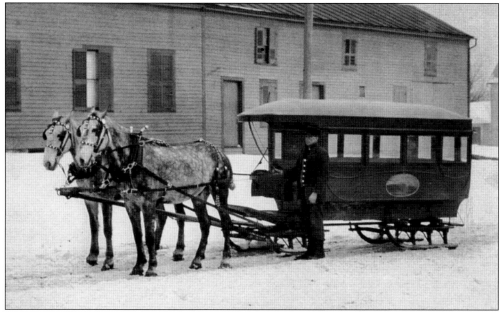

W.C. Camp & Son Bus and Dray Line operated sleighs in the winter and horse-drawn busses in warmer weather. They carried freight and passengers to and from the town to the railroad station two miles away. Since several trains a day stopped at the station, business was brisk. They advertised, "Prompt attention given to all businesses in our line" and "Hacks to and from all trains."

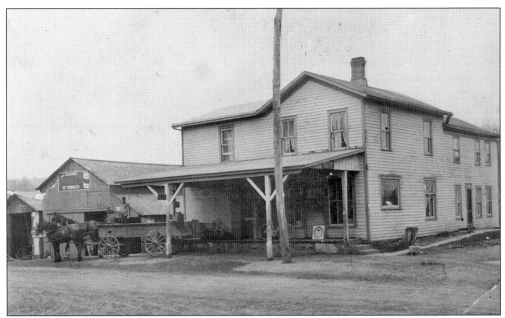

Zack Brace's business was located across from the Waterford railroad station in the late 1800s. They advertised items for sale, such as coal, cement, roofing, and sewer pipe. Brace sold the business to Gillette & Phelps, and in 1922, E.L. Heard purchased the business from them. After his son William became a partner, the business became E.L. Heard & Son and continues by that name today under the ownership of third-generation David Heard.

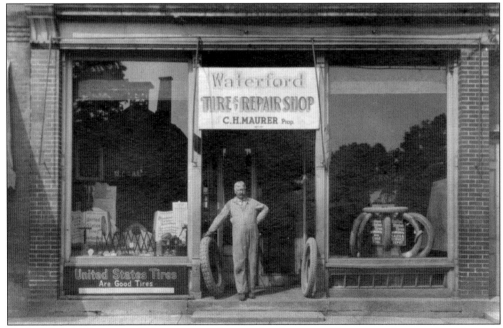

Casper "Cap" Maurer could be seen standing in the doorway of his tire and repair shop, located on West Main Street, most days of the week. "Cap" came to the United States from Switzerland in 1885 and settled in Warren, eventually moving to Waterford. He was proprietor of the Park House Hotel and built the brick house and gas station on East Main Street north of East Sixth Street.

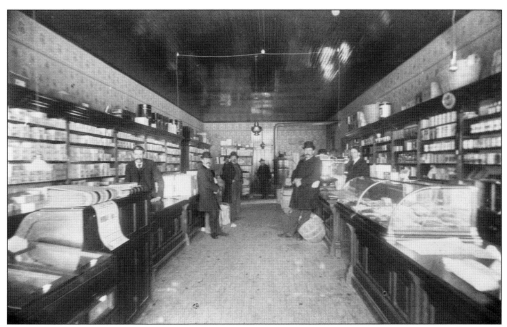

There was always something going on at Patten's General Store, located on the southwest corner of West Second and Main Streets. It was a gathering place for townspeople on cold winter days. The stove remained in place until 1952. On the left are Marion Patten, Paul McKay, and Bill Davis. On the right are Park Shaw and Rollo McCray. The three people in the back are unidentified.

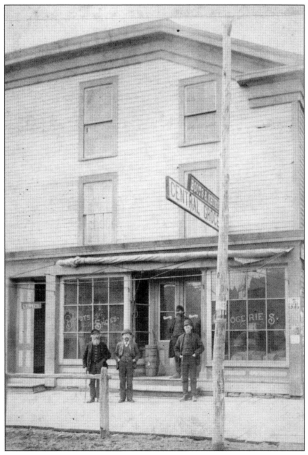

Four gentlemen stand in front of the Patten Central Grocery shortly before a fire consumed much of the block on March 3, 1895. After the fire, it was rebuilt in brick and called Patten & Company. Rollo McCray, Marion Patten's half-brother, became a partner in the store around 1900.

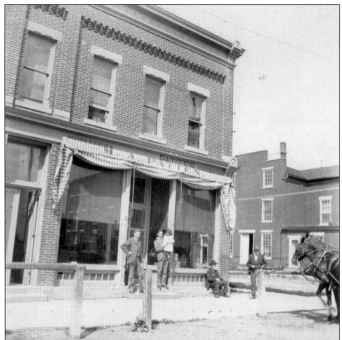

Patten's store, along with most of the buildings on the west side of Main Street, was rebuilt in brick after the fire. Shown here celebrating a warm spring day in front of the recently reopened store are, from left to right, Marion Patten, Rollo McCray holding a child, Noah Porter, and Alden Stancliff.

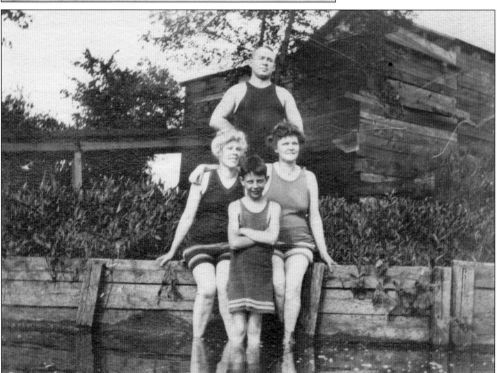

While out for a swim, C.W. Bowen, Mrs. Witte, Mrs. Phipps, and Albert Witte take time to pose for a photograph in front of the old icehouse at the outlet of Lake LeBoeuf. Ice was cut on the lake in the winter, packed in sawdust, and stored in the thick-walled icehouse. Ice could last most of the summer if kept in this way.

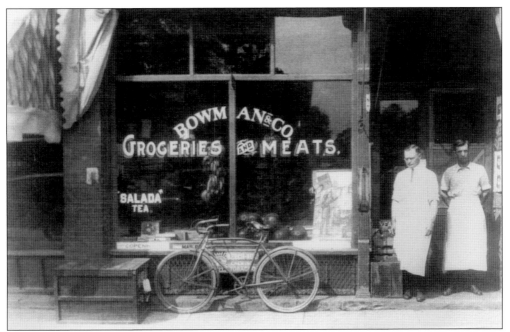

Bowman & Company Groceries and Meats was located on the west side of Main Street between First and Second Streets. Owners J.B. Bowman and A.N. Dennington are shown here in 1916. Their motto was "Complete stocks to meet every reasonable demand." Irwin and Cross owned the store from the 1920s until the 1950s, when Pete Haskins and Earl Stafford acquired it.

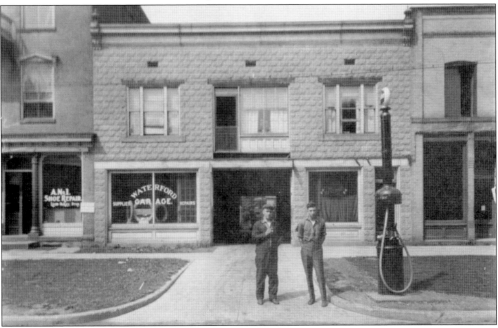

Lawrence Burdick (left) was proprietor of the Waterford Garage from the late 1930s through the 1940s. The automobile repair shop, which was the cement block building, was one of the Main Street businesses that thrived in that era. The garage was located north of the three-story brick building on the corner of West First Street that housed a furniture store and a shoe repair store.

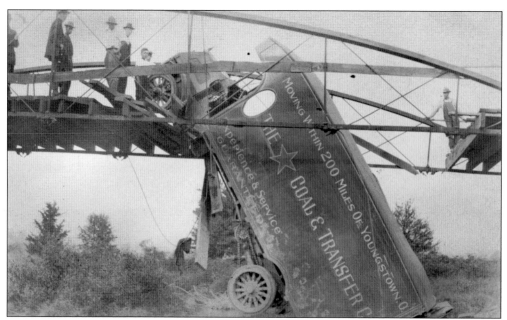

Bridges built for horses and wagons were not always sturdy enough for heavy, modern trucks. A crowd gathered in July 1918 when this Coal & Transfer Company truck fell through the High Street Bridge, which crosses LeBoeuf Creek at the inlet of the lake. Roscoe Mitchell, a noted area horseman, won local acclaim when he managed to pull it out with his team of prizewinning draft horses.

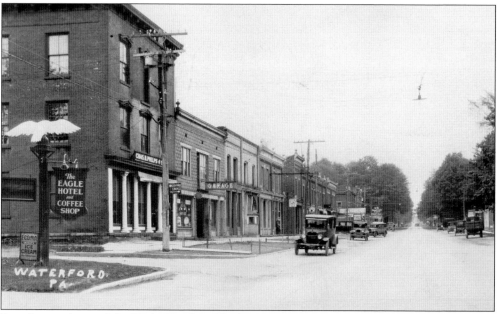

Standing in front of the Eagle Hotel and looking north on High Street, a view of downtown Waterford can be seen. Visible are Charles Phelps & Sons, the Waterford Garage, and even the ticket booth in front of the LeBoeuf Theater. The carved eagle, the hotel's trademark, is now owned by the Pennsylvania Historical Museum in Harrisburg. The Fort LeBoeuf Historical Society had a replacement carved, which is now on display.

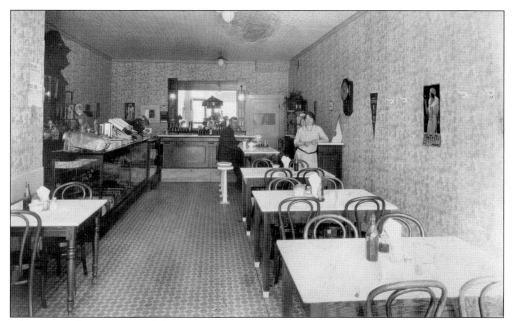

The Twitchell family owned the Gem Restaurant. They lived just outside of Waterford Borough in Waterford Township. The restaurant was located on West Main Street between the park and West Second Street. It was a popular place to stop on the way home from school for a coke or one of their 25¢ pecan sundaes. Ruth Barnett, a waitress at the restaurant, stands at the counter while George Hart enjoys his morning cup of coffee.

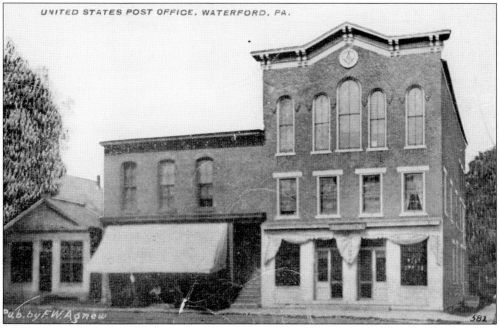

From 1913 until the early 1940s, the US Post Office in Waterford was located on the corner of East Main and Second Streets. It occupied the first floor of the Masonic Building, which had been constructed in 1840. Postmasters during that time were James Alcorn, Charles Schlosser, and Charles Shaw. The Civil War Recruitment Center is in the small building on the far left.

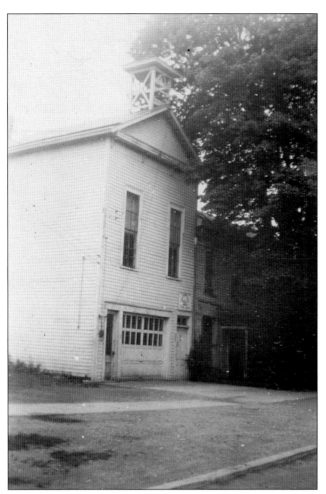

This small building housed the Waterford Borough Hall, the town library, the jail, and the Eagle Hose Company. After a fire, the hoses were hung to dry from the platform on the roof. It was located on East Main Street near the corner of East Second Street, now the site of PNC Bank.

The Merrell Soule Milk plant at the Waterford depot produced condensed milk, egg powder, mincemeat, and various canned goods. This factory employed about 20 people. There was another plant in nearby Union City, Pennsylvania, and the headquarters was located in Syracuse, New York. The site is now a cornfield. Borden acquired Merrell Soule Milk in 1927.

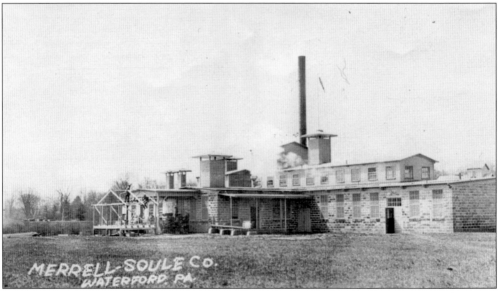

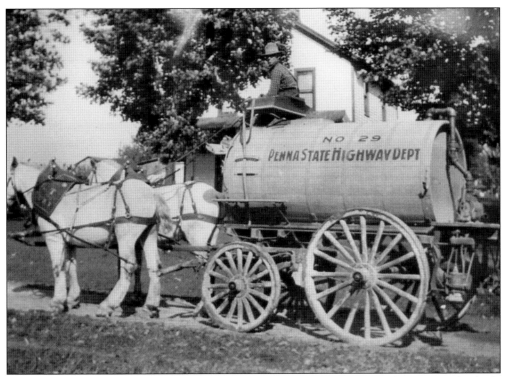

Here is an example of an early Pennsylvania Department of Transportation (PENNDOT) vehicle at work. Before roads were paved, the highway department used horse-drawn tankers, like this one, to sprinkle water on the roads in an attempt to keep down the dust. The driver is Reed Hunt, son of Simeon Hunt, an early Waterford settler.

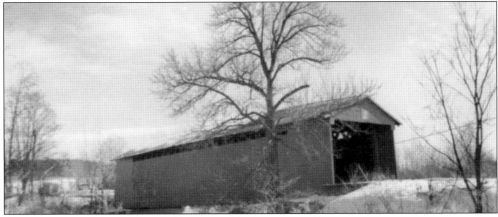

The Waterford, or Brotherton's, covered bridge crosses LeBoeuf Creek on Niemeyer Road about a mile and a half from town. Built by the Phelps Brothers between 1865 and 1875, it is of wood lattice truss construction. Tapered oak pins, ranging in length from six to 14 inches, hold the trusses together. It is 78 feet long, 15 feet wide, and has a 10-foot clearance.

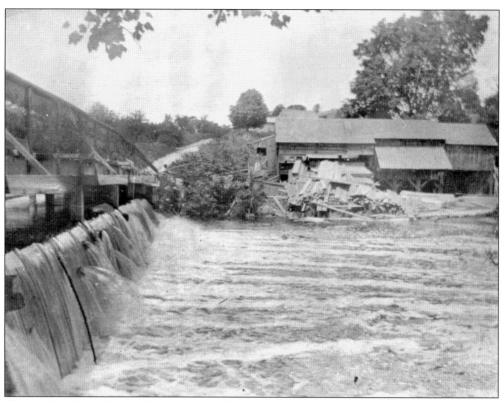

This is thought to be the Brotherton Mill on LeBoeuf Creek. It is typical of the many saw, shingle, and lath mills that operated here in the early days. Robert Brotherton started the first mill in the area in 1806. The Bensons, Lattimores, Whitneys, Marshes, and Judson and Hipple owned other mills.

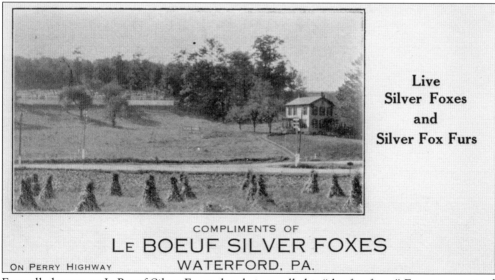

Live
Silver Foxes
and
Silver Fox Furs

COMPLIMENTS OF
LE BOEUF SILVER FOXES
ON PERRY HIGHWAY WATERFORD, PA.

Formally known as LeBoeuf Silver Foxes, locals just called it "the fox farm." Foxes were raised here commercially for the fur industry. Owned by Joe and Bernice Edmond, it was located at the north junction of Routes 19 and 97. Humes Auto Sales now occupies the site.

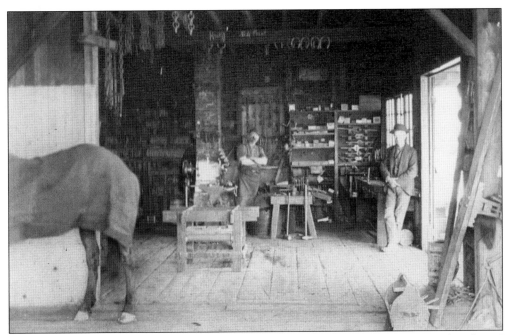

In the early days, the blacksmith shop was very important to the community. Metal tools and implements for farms, homes, and businesses were fabricated here. In addition to fabrication, the blacksmith was responsible for trimming the hooves and shoeing the horses, which were the primary means of transportation well into the 20th century. This blacksmith shop, which belonged to H.D. Hovis, was located on the corner of Third and Chestnut Streets. These photographs, showing both the interior and exterior of the building, were most likely taken in the mid-1800s. The shop eventually closed, probably in the mid-1940s, and the building has since been used as Jerry Gilmore's insurance office and then Rick Gilmore's dance studio. It is still standing and is now used as a private residence. (Courtesy of Anita Palmer.)

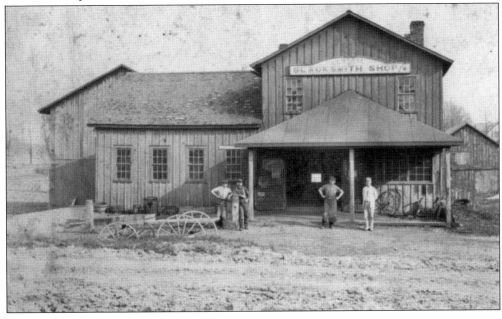

This building at West Second and Walnut Streets was the home of H.O. Woodard, who managed the new Erie County Telephone Company of Waterford. The switchboard was located upstairs in one of the rooms. W.K. Andrews incorporated the Erie County Telephone Company in 1909 to service the areas of Waterford, Mill Village, and the surrounding countryside. They offered affordable rates for both business and residential customers.

50

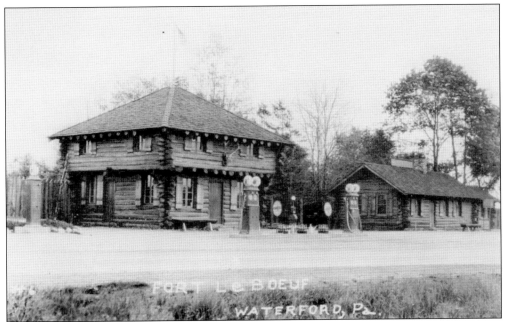

Located just south of town at the junction of Routes 19 and 97 and known to locals as "the Y," this replica of Fort LeBoeuf was a Pennzoil gas station. To the right of it is the Log Cabin Restaurant. Both were owned and operated by Stanley and Winnie Boarts. The restaurant burned in the 1990s, and the gas station building was relocated and is now the offices of Hurst Potato Sales.

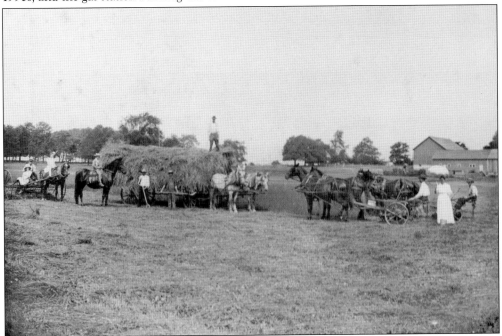

The typical farming scene in the early days would include neighbors helping neighbors bring in their crops for the season. Everyone would turn out to help, as there was much work to be done. The women always provided plenty of food for all who came to lend a hand and treated them like family. The lady with the parasol, no doubt, came to the field to invite all to dinner.

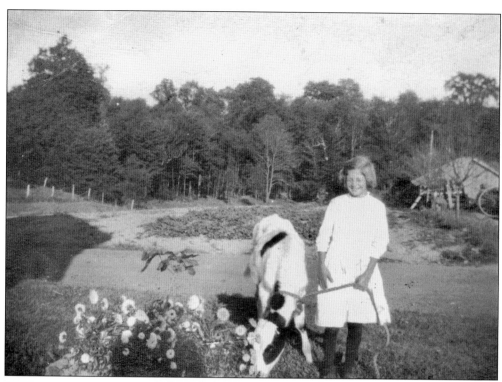

Viola Wagner and her friend Bessie take a leisurely Sunday stroll to smell the daisies and escape the drudgery of daily chores. Taking care of the animals on the farm was part of a child's routine, along with gathering eggs and doing the dishes, all before heading off to school.

Beverly Owens (left) and Amber Owens are getting a lesson in how to milk a cow from their father, Everett. In the early 1930s and 1940s, Everett Owens kept his cow in a little barn on Walnut Street and could be seen every morning and evening carrying his pail of milk to his home on Fourth Street. Early settlers kept a cow, pigs, and chickens in their backyards.

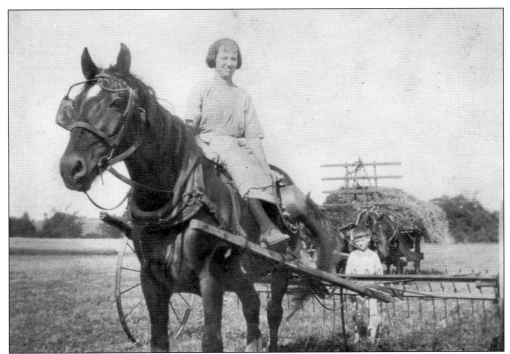

In 1919, hay had to be pitched on to the wagon by hand, and it was a very difficult chore. After family members loaded the wagon, Margaret Wochner sat on the horse and posed for this photograph. Her brother Bill is checking out the hay rake. Margaret decided that farm life was not for her and shortly after this photograph was taken, she moved to Erie and sought a more "ladylike" career.

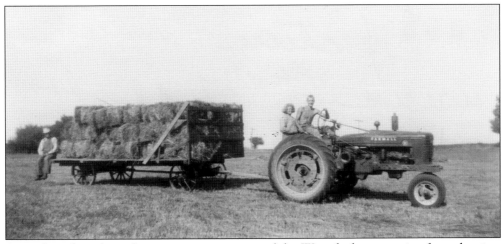

Agriculture has always been an important part of the Waterford community, from the time of the earliest settlers. Methods have really progressed from using horse-drawn implements to tractors. Valentin Ostermann Jr. and his sister Anna are pictured in the 1940s hauling a load of hay to their barn, located on Old Route 19, with their new tractor when Valentin Sr. decided to catch a ride on the wagon.

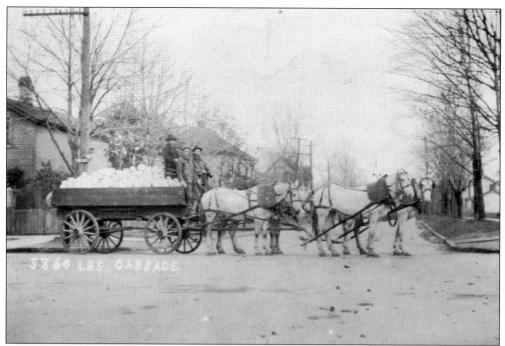

Raising cabbage has been an important commodity for Waterford Township farmers. This load of cabbage weighed 5,860 pounds and is on its way to the Waterford railroad station, where it will be loaded on the train and shipped to commercial buyers. Frank Woods is driving the four-horse hitch, along with two unidentified men.

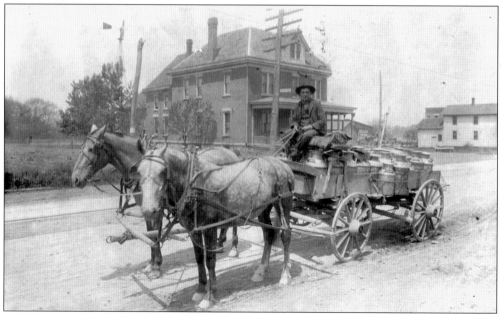

Long before bulk milk trucks were invented, farmers had to put their cows' milk in 10-gallon cans to be picked up by haulers, who would take the milk to nearby processing plants. Frank Woods used his horse and wagon to take his and his neighbors' milk to perhaps the Union City milk plant.

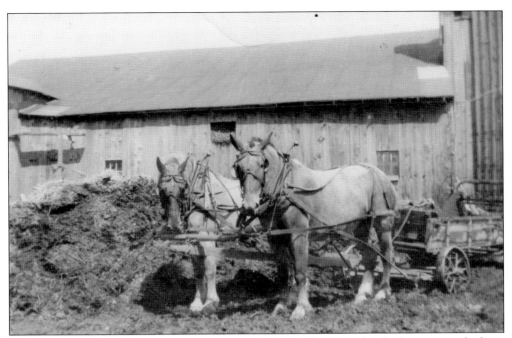

Draft horses named Rusty and Dolly wait patiently for the farmer to finish cleaning out the barn and pitch it on the spreader so they could haul it out to the fields to be used as fertilizer. In 1944, there were no automatic barn cleaners to ease the backbreaking process of cleaning the trenches inside the barn.

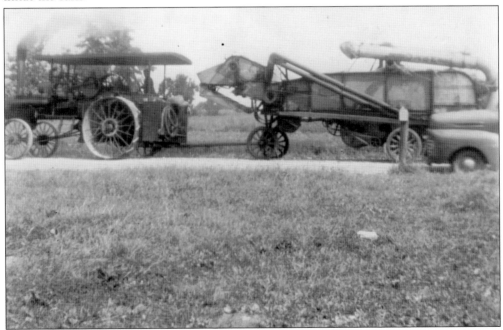

In the early 1940s, the Klakamps owned an old steam tractor that they would use to haul their new threshing machine. Owners of threshing machines would travel from farm to farm to thrash the farmer's grain. This would be quite an event, as all the neighboring farmers would pitch in to help each other, thereby making a hard task tolerable. (Courtesy of Retha McGahen.)

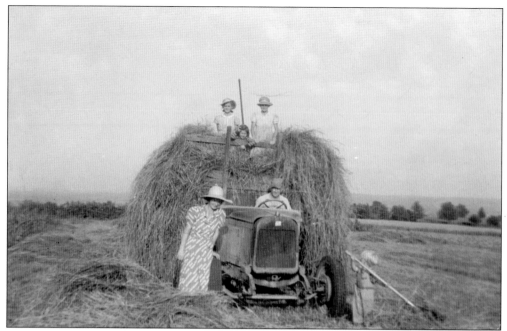

After loading this wagon full of hay with pitchforks in the early 1940s, members of the McGahen family of McGahen Hill Road take some time out to rest. Gladys McGahen is standing beside the tractor; the twins, Lois and Louise, are on top of the load; and little Wesley is standing holding a pitchfork. The others are unidentified. (Courtesy of Retha McGahen.)

Lee Smith had just purchased his first rubber-tired manure spreader for his farm in the early 1940s. After looking it over, his family, who were all dressed for church, decided to climb in and have their photograph taken. They are Lee (holding the reins); his wife, Edna; their children Sidney, Audrey, Paul, and Helen; and Grandpa Smith. (Courtesy of Hubert Smith.)

Five

ORGANIZATIONS AND SOCIAL CLUBS

Gathering together in groups for a certain purpose is something people have done since the beginning of time. In the Waterford area, people have gathered together for nearly every reason imaginable. Some of these organizations are still well known, while others have been long forgotten.

There have been fraternal orders, such as the IOOF (Independent Order of Odd Fellows), the Masons, and their female counterparts, the Eastern Star. The ELS (Everett Literary Society) and the Chautauqua Reading Group were formed to discuss literature. Patriotic and historical groups, such as the DAR (Daughters of the American Revolution), the DAC (Daughters of the American Colonists), the Fort LeBoeuf Historical Society, and the Boy Scouts and Girl Scouts, help people learn about and preserve the past. There have been veterans groups like the American Legion and the GAR (Grand Army of the Republic), which was a Civil War veterans' organization that honored the bravery and sacrifices of the men and women in the military.

Temperance groups like the WCTU (Women's Christian Temperance Union) were formed to combat alcohol abuse. Undoubtedly, there is still a chapter of Alcoholics Anonymous in the area. Some clubs, however, were strictly social. The JAG (Just All Girls) and the Ladies Aid would have been in this category, but even they had service projects. There were, and still are, at least two garden clubs whose purpose is the beautification of Waterford. There were school groups, church groups, musical groups, and sports teams. Organizations like the EAU (Equitable Aid Union) and the Grange were formed, in part, to provide group insurance rates for their members. The Lions and Lioness Clubs and the volunteer fire departments were formed to provide a service.

In this farming community, there were organizations based on agriculture, like the Patrons of Husbandry (Grange), the Dairymen's League, the FFA (Future Farmers of America), and 4-H. To showcase the bounty of the harvest, the Waterford Fair was organized.

The list of clubs, societies, orders, groups, and organizations is endless. There is room for only a few photographs of them, but they all, in one way or another, contributed to the development of the community.

The first Waterford Street Fair was held on August 21, 1896, in the downtown square in conjunction with the 12th Annual Firemen's Parade. It was held with the intention that if the immediate and surrounding community met it with favor, it would become an annual event. There were no cash prizes offered, but a merchant chose every prize awarded from his stock.

The first Waterford Community Fair was held in 1937 on the baseball field and in the school auditorium. It was, and still is, primarily an agricultural fair, with horse-pulling contests, exhibits of all types, and entertainment. It outgrew the original site, and the new fairgrounds were dedicated in 1970 at the present location on Route 19 and Seroka Road, where it continues to flourish.

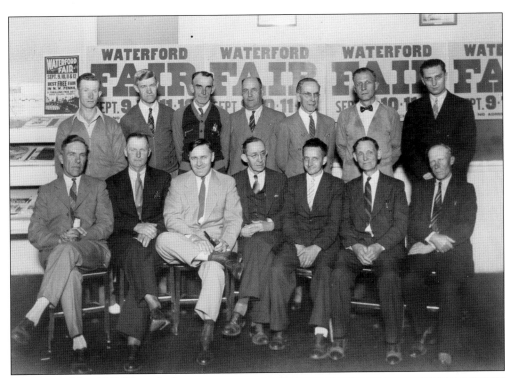

Directors of the 1942 Waterford Community Fair were all prominent and active members of local affairs. From left to right are (seated) E.L. Heard, Roscoe Mitchell, Paul Babbitt, Charles Shaw, Ray Salmon, Harry Merritt, and John Schwab; (standing) Clifford Haynes, Lee Thomas, Frank Woods, Paul Bartholme, Rollo McCray, Floyd Irwin, and Melvyn Shields.

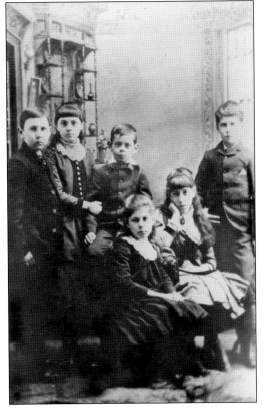

The Little Six gained nationwide recognition in 1884 when the children arranged a performance to raise money to help victims of the floods on the Ohio and Mississippi Rivers. They raised $51.25, which was telegraphed to Clara Barton at the Red Cross. The donation was used to help rebuild the Plew home, which was known as "The Little Six." The children ranged in age from six to 12 years old. Their names were Zoe Farrar, Florence Howe, Mary and Lloyd Barton, Reed White, and Bertie Ensworth.

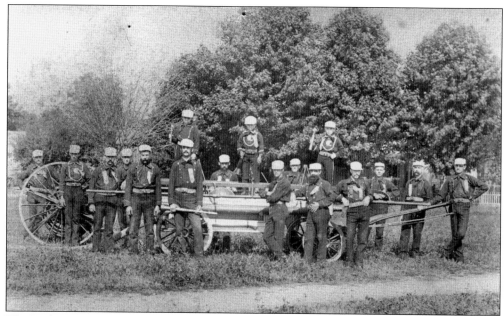

The Eagle Hose Company met as early as 1839 and formally organized in 1884. The first chief was William Hovis, second from left. Next to him is George Hovis, and on the right is Harry Merritt. Others are unidentified. In 1925, A.J. Stancliff gave the fire company a White automobile, which had been rebuilt as a fire truck. The company was renamed the Stancliff Hose Company in his honor and is still known by that name.

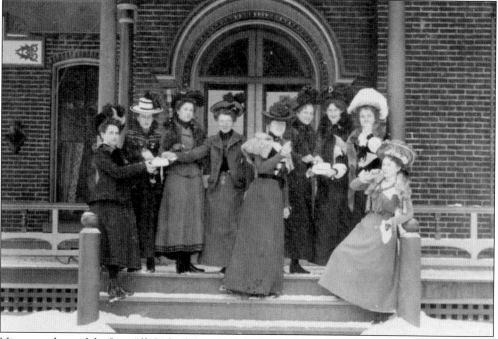

Nine members of the Just All Girls club, called the JAG, show off their winter finery in this New Year's Day 1901 photograph in front of the Blystone House, also known as the Waterford Hotel. The JAG was an organization of young women from prominent Waterford families.

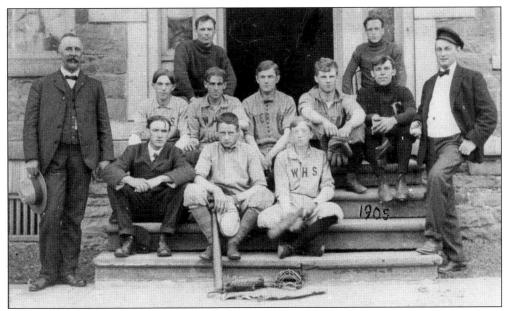

Fancy uniforms were not a priority for the 1905 Waterford High School boys' baseball team. Most of the members used their own bats and gloves to play the game they loved so well. The members are not identified, but the gentleman on the left could be the principal of the high school, while the one on the right is most likely the coach.

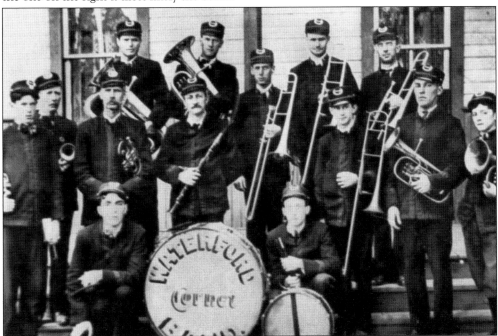

The Waterford Cornet Band of 1909 was one of many musical groups that entertained the residents of Waterford in the days before radio and television. Pictured are, from left to right, (first row) Harry Heard and Billy Hovis; (second row) Lester Phillips, Charles Phillips, A.J. Hewitt, Will McKay, Edson Erskine, "Jet" Feidler, E.L. Heard, and Larry Taylor; (third row) Will Strain, unidentified, Bert Dennington, and Ed Wilder.

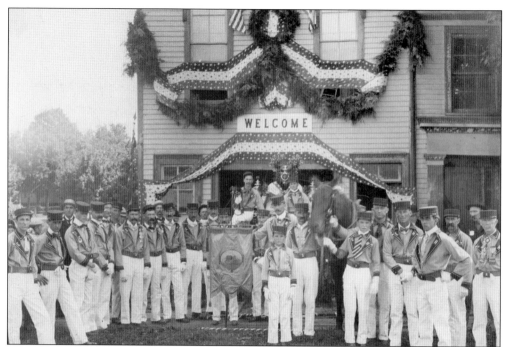

The Eagle Hose Company would begin formation for any parade in front of the Waterford Borough Building, where they housed their fire equipment. The members from left to right are Roy Roberts, Harry Merritt, Barton Kelly, Jim Phelps, Wright Gilbert, Frank Judson, Horace Hovis, Mel Fritts, Mr. Perry, Harry Bolard, Charles Phelps, Miles Houghton, Jim Kirk, John Judson, Jet Fiedler, "Pelee" Sedgwick, Seth Fiedler Jr., Lynn Phelps, Jim Shields, Bruce Owens, Rollo McCray, Seth Fiedler Sr., and Chris Gray.

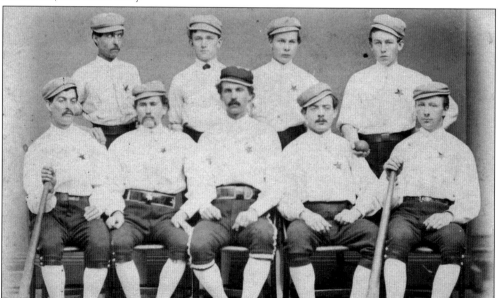

The Waterford Academy baseball team poses for the team photograph. Not all of the players can be identified, but in front on the left is Christopher Gray. In the second row, second from the left is Tell Fish, brother of Ruth Fish Russell of Russell Furniture Store, and at far right is Fred Whitney.

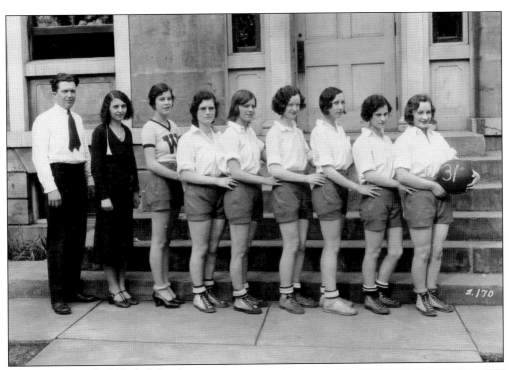

The 1931 Waterford High School women's basketball team was an extremely athletic group that brought many honors to the school with their skill and strength. Pictured from left to right are R.A. Strang (principal), Cornelia McKay, Thora Delavern, Christina Bittles, Iva Donnell, Norma McLallen, Helena Hovis, Dorothy Kennedy, and Mary Popovich.

Reed Hunt (left) and Charles Schlosser are pictured wearing their sports uniforms of Waterford High School. As an adult, Hunt built the house on the corner of East Seventh and High Streets. For some time, he worked for the Pennsylvania Highway Department. Schlosser became the Waterford postmaster from 1922 until 1935. At that time, the post office was located in the Masonic building on the corner of High and East Second Streets.

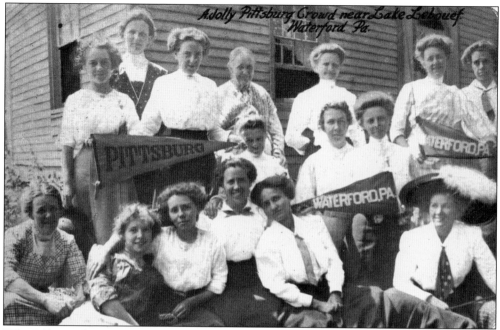

"The Jolly Pittsburgh Crowd" was a group of girls and women who traveled from Pittsburgh to vacation at Lake LeBoeuf every summer. Unfortunately, they are unidentified. Included in this photograph, though, are three local girls: Georgia Phelps, Annabel Kirk, and Helen McKay; which ones they are, however, is unknown.

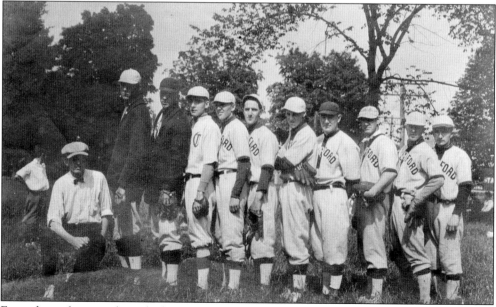

From the early years through the 1940s, each community had a baseball team that competed against each other. When Waterford hosted a rival team, the games were held in the east park in the center of town. The townspeople really supported their team. The Waterford town baseball team would pose for a photograph to mark the beginning of the season.

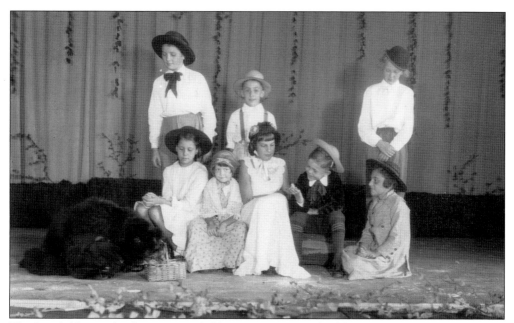

The first children's school pageant was held in August 1934 to the delight of parents and townspeople. At that time, the entire town would turn out for an event to support the organization, and it was usually the only entertainment around. The participants of the pageant are, from left to right, Martha Fuller, Eldon Sturrock, Marian Mahan, Barbara Lamberton, Ruth Bensinger, Joan Fuller, Junior Hare, and Viola Donell.

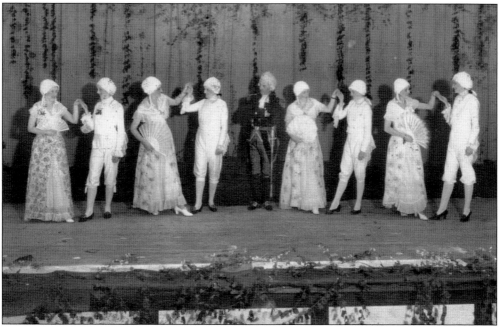

The Spirit of LeBoeuf was a pageant presented by the Daughters of the American Revolution in 1934. It was advertised as "An Epoch of Waterford History." Dancing the minuet are, from left to right, Veda Camp, Grace Wilder, Virginia Briggs, Helena Hovis, Annabel Fuller, Myrtella Shaw, Ethel Irvin, and Elizabeth Harper. In the center is George Washington, played by W.E. Briggs.

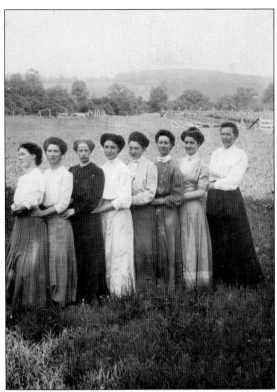

A group of young ladies, all from prominent Waterford families, pose for a late-1920s photograph while on a field trip to a local farm with their teacher. Pictured from left to right are Beatrice (Sherman) Port, Carrie (Brace) Carey, Rena (Trask) Mahan, Nellie (Hunter) Holmes, Mary (Avery) Taylor, Luella (Benson) Moore, Eva (Rice) Coover, and Emma Hunter.

It is believed that this photograph was taken around 1875. The young women in the group are, from left to right, (first row) Ida Gaste, Gertrude Himrod Hagerty, and Gertrude Lyle Waggoner; (second row) Margaret Strong, Jessie Benson Sargent, Kate Strong Lear, Jessie Judson Lamberton, and Mary Ensworth Benson; (third row) Jennie Taylor, Minnie Farrar Arbuckle, Mattie Waggoner Shaw, and Sally Strong VonSenden.

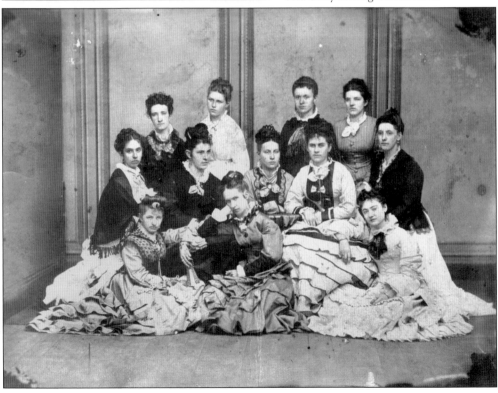

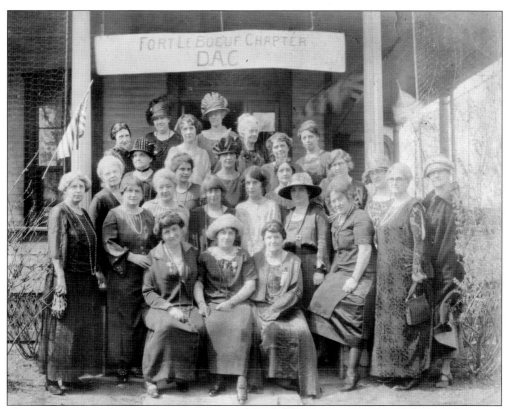

The Fort LeBoeuf chapter of the Daughters of the American Colonists was organized in 1923. The object of the society, in part, "shall be to be patriotic, historical, and educational; to make research as to the history and deeds of the American colonists; and to record and publish same."

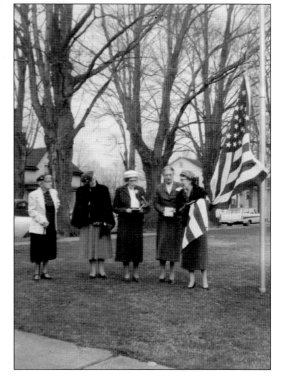

Members of the Waterford chapter of the Daughters of the American Colonists perform a flag-raising ceremony in August 1957. Pictured from left to right are Lulu Phelps of Waterford, Kate Patterson of Corry, Evangeline Barnes of Waterford, Helen Schluroff of Erie, and Irene McLallen of Waterford.

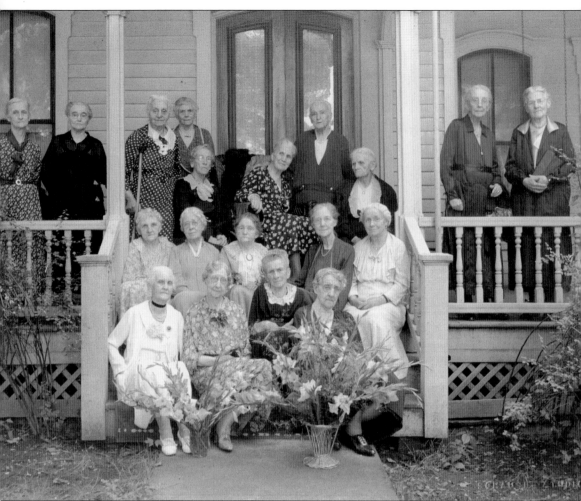

A gathering of the octogenarian ladies of Waterford in September 1936 brought a group together that ranged from 80 to 88 years of age. Between them, they had 60 children, 80 grandchildren, and 24 great-grandchildren. The event was held at the home of Jane Bolard. Maria Fish, the oldest lady in Waterford, gave the invocation, after which refreshments were served and songs were sung. The assembly ended by singing "Till We Meet Again" and all hoping to get together the next year. Pictured are, from left to right, (first row) Emma Merritt, Lucina Putnam, Lillian Cross, and Mary Ensworth; (second row) Mrs. Charles Burns, Susan Cross, Emma Schlosser, Kate Walker, and Mary Shaw; (third row) Mrs. Hanford Skinner, Mrs. Claude Sedgwick, Valores Barnes, Marie Fish, Viola Burton, Jessie Russell, Anna Titus, Mrs. J. H Coon (of Cleveland, Ohio), Emma Woods, and Eva Port.

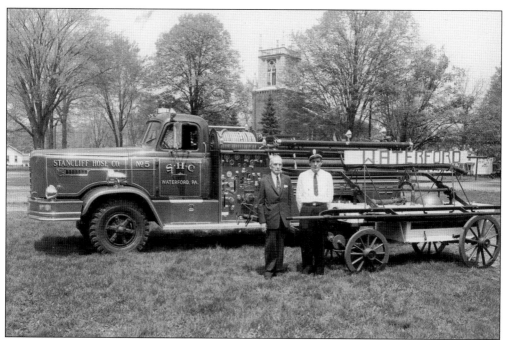

Rollo McCray and Rexford Scott are pictured with the Stancliff Hose Company's new fire truck in the 1940s. The old hand pumper is in the foreground. The new truck was housed in part of the Humes Auto and Tractor Sales structure before the firehouse was constructed in the park, where the library and borough building are now located.

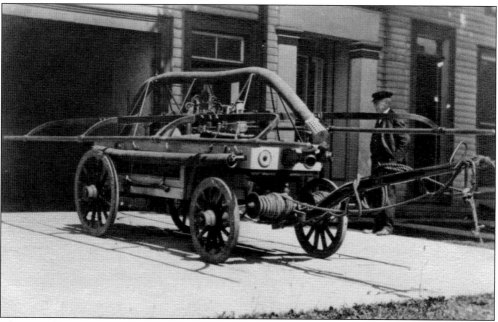

The 1830 hand pumper was purchased by Rufus R. Reed on August 15, 1884, and stayed in his possession until it was sold to the Waterford Borough. F.E. Ensworth, standing beside the pumper, was foreman of the Eagle Hose Company at the time. Waterford Borough still owns the pumper, but it is on loan to the Firefighters Historical Museum in Erie.

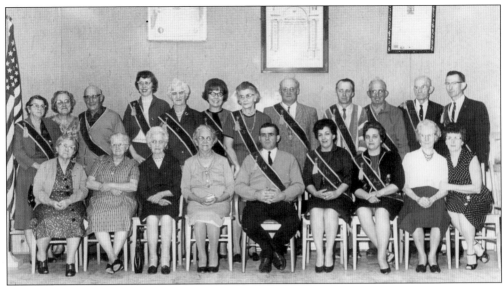

After a meeting of the Waterford Grange No. 423, founded in 1874, the officers and members posed for a group photograph. They are, from left to right, (seated) Iva Ishman, Dorothy Woods, Gertrude Marsh, Cherity Nye, Howard Proctor, Dorris Proctor, Louella Haynes, Eva Haynes, and Doris Hakkarainen; (standing) Clara Welch, Gertrude Goldsmith, Ray Welch, Joyce Nye, Gertrude Nichols, Myrtle Nye, Rowena Hazen, Arnold Hakkarainen, Gene Smiley, Wade Ishman, Frank Nye, and Clifford Haynes.

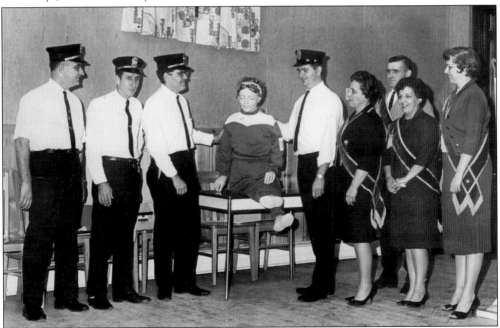

During a special meeting of the Waterford Grange No. 423, members of the Stancliff Hose Company conducted a demonstration of how to give CPR using their "Resusci Annie" dummy. The Hose Company volunteers are, from left to right, John Whittelsey, Dick Gehring, Gerald Roberts, and Merle Wilmire. Officers of the grange are, from left to right, Louella Haynes, Howard Proctor, Dorris Proctor, and Joyce Nye.

Frank Ensworth was a Past Master of Waterford Lodge No. 425 of the Free and Accepted Masons, member of the ancient Arabic order, Nobles of the Mystic Shrine. Born in Wattsburg on July 22, 1852, he moved to Waterford in 1867. He was a tinsmith by trade and opened a general hardware business and a bank. He married Mary A. Roberts. Frank took considerable interest in public affairs and was the Pennsylvania alternate delegate to the 1916 Democratic National Convention.

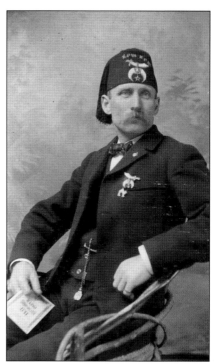

The Fort LeBoeuf Chapter 487, Order of the Eastern Star, was the ladies' counterpart of the Free and Accepted Masons. This photograph is of the 1948–1949 corps of officers. From left to right are (seated) Lillian Wells, Sabra Bartholme, Ruth Manross, Rhea Jenkins, Blanche White, Lillian Mallory, and Lillian Porter; (standing) Frances Johnston, Annie Black, Ruth Humes, Bernice Edman, Harriette Hager, Elizabeth Shallenburger, Ruth Russell, Melva Lee, Grace Alcorn, and Gertrude Brown.

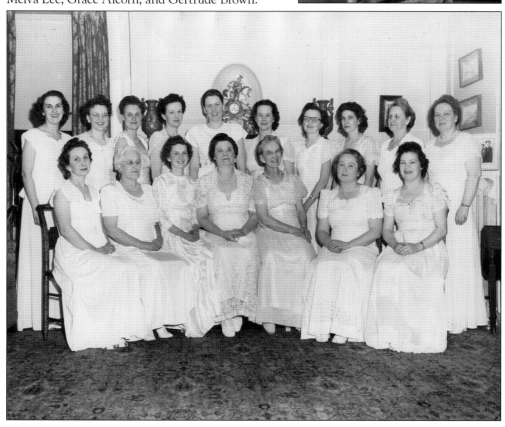

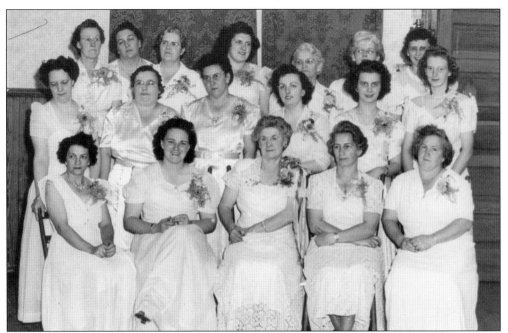

The Calla Rebekah Lodge No. 286 of Waterford was the ladies' counterpart to the Independent Order of Odd Fellows. From left to right are (seated) Irene Anderson, Julia Carniewski, the installing officer, Nellie Fox, and Ruth Chapman; (second row) Mickey Ober, Viola Fox, Johanna Hull, Autumn Shields, Dorothy Chapman, and Sennie Eliason; (third row) Nina Thompson, Naomi Clute, Blanche Millike, Florence Carniewski, Helen Heard, Christina Burdick, and Myrtle Feasler.

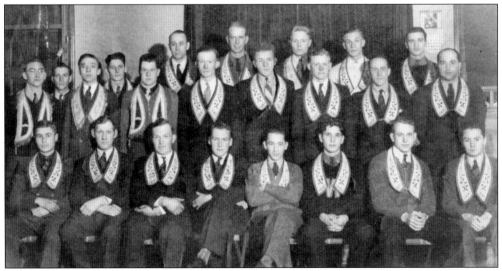

The Independent Order of Odd Fellows, established in 17th-century England, is a fraternity dedicated to benefiting mankind. This c. 1935 photograph was taken in Heard's Hall. Pictured are, from left to right, (first row) William Himrod, Clarence Mitchell, Cecil Hull, unidentified, Charles Schlosser, Neil Bartholme, George Egelin, and Dean Schlosser; (second row) unidentified, David Burns, Morris Hilliker, Clifford Haynes, Steve Halmi, Eugene Mitchell, Walter Bowersox, and unidentified; (third row) three unidentified men, Clarence Gibson, unidentified, Joseph Weber, and Curtis Walker. (Courtesy of William Himrod.)

Six

SCHOOLS AND CHURCHES

Early settlers believed education and religion were very important, so they established schools and churches from the very beginning. As early as 1806, there was a school in Waterford where Russell Stancliff taught. The Waterford Academy opened in 1826 and was the first school of higher education in Erie County. A number of its graduates went on to Yale, Harvard, and other eastern universities. For those unable to go to the academy, there were one- and two-room schoolhouses throughout the community. Over the years, there were more than 30 of these small schools in Waterford, Waterford Township, LeBoeuf Township, and Mill Village. A few schools that some might remember are Bagdad, Depot, Sharpe, Mallory, Oak Grove, Bonnell, Strong, Barton, and Union. Gradually, these schools were consolidated, and by the mid-1950s, all were incorporated into the Fort LeBoeuf School System.

There are photographs of the Presbyterian, Methodist, Catholic, Nazarene, and Episcopal churches in Waterford. Presently in the borough of Waterford, there is also St. Mark's Lutheran Church and the Waterford Baptist Church; in Waterford Township, there is Harmony Baptist Church. Historically, in Waterford Township, there were two Free Will Baptist Churches, a Methodist Episcopal Church at Sharpe's Corner, and a Christian Church. In LeBoeuf Township, there was a Methodist Episcopal Church and a United Brethren Church. Just north of the intersection of Routes 19 and 6 North, the Manross Church was built in 1869. The structure is still standing but is in very poor condition. Near Mill Village, a Methodist Episcopal congregation was formed before 1810. Circuit-riding preachers conducted services for them about once a month. They met in private homes until a church was built in the 1850s. A Presbyterian congregation was organized in Mill Village in 1870, and a building erected in 1872. The Reverend M. Wishart, also pastor of the First Presbyterian Church in Waterford, was pastor there in 1884.

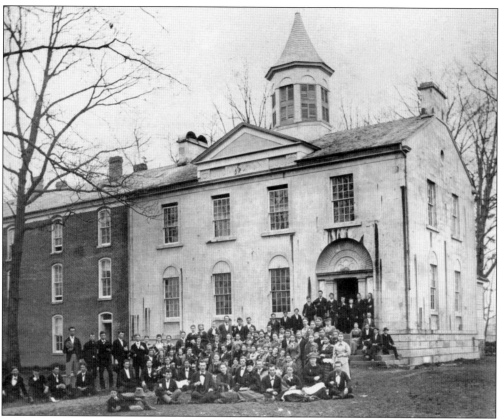

In 1811, Sen. Wilson Smith of Waterford was instrumental in obtaining a charter for the Waterford Academy. He was a trustee from 1813 to 1834 and was often called the "Father of the Academy." The charter included a land grant of several pieces of property to be sold to obtain funds for the academy building. William Black, a noted mason from Pittsburgh, was hired to quarry the stone from an area off Oak Hill and lay up the stone walls. He also had to be assured of room, board, and a barrel of whiskey. Robert Brotherton provided the lumber, and Timothy Judson did the plastering of the walls. In the beginning, the upper story was set aside for public worship. In a public notice, the trustees resolved to open a public school in the academy on December 1, 1826.

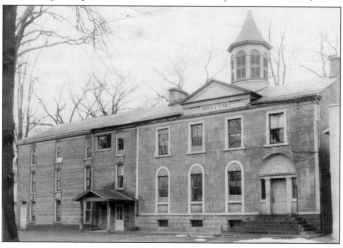

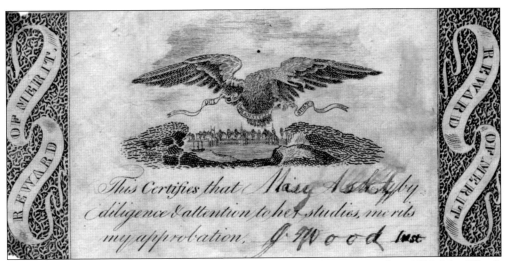

A certificate of merit from the Waterford Academy was issued to Mary Ash in 1830. John Wood, the first headmaster of the school, signed it. He came from England in 1825 to take the position. He was the grandfather of Marjorie McKay Richardson, a well-known resident of the community.

This portrait of the Hiscox family was taken while Mr. Hiscox was principal of the Waterford High School, formerly the Waterford Academy, in the 1920s. His daughter Ethel (standing in the back) went to Europe during World War I to entertain the troops.

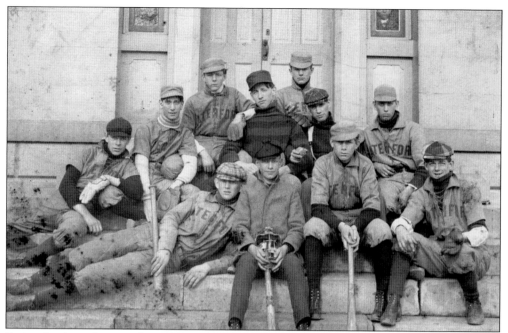

Posing for their photograph in 1900 is the Waterford Academy baseball team. Pictured are, from left to right, (first row) Walter Schlosser, Timmie Barber, Roy Fritts, and Harlow Stafford; (second row) Barton Kelly, Clayton Phillips, Charles Schlosser, Frank Patterson, Raleigh Barnes, Arthur Ensworth, and Reed Hunt.

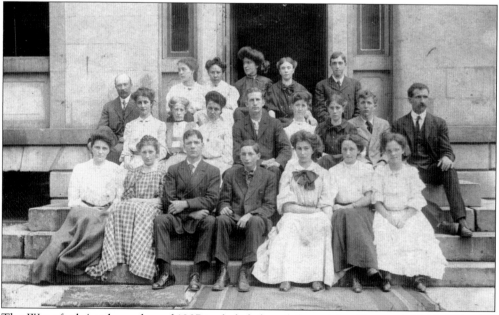

The Waterford Academy class of 1907 included, from left to right, (first row) Mable Wheeler, Blanche Barnes, George Stafford, James Donnell, Grace Hull, Emma Schlosser, and Anna Lockwood; (second row) E.M. Mixer, Eva Rice, Ann Trask, Nellie Hunter, Edwin Camp, Luella Benson, Mary Sybrandt, Glenn Houghton, and unidentified; (third row) Beatrice Sherman, Abbie Wade, Mona Feidler, Grace Sybrandt, and Earl Campbell.

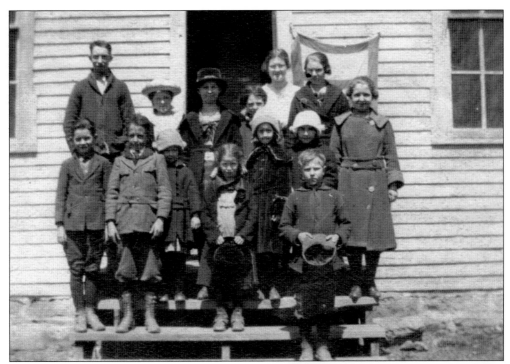

This is the 1919 class photograph from the Depot School, which was taught by Florence Whitney. The class consisted of Eleanor Owens, Lawrence Owens, Harry Young, Charlotte Moore, Genevieve Estes, Mary Deland, Mildred Owens, Neal Estes, Clarence Whitney, Irene Snow, Marian Moore, Florence Whitney, Olibelle Snow.

Elizabeth Saeger, a teacher at the Depot School, is pictured on March 31, 1919, chopping wood as part of her vocational duties. This—as well as building the fire in the morning, keeping it going, cleaning the schoolhouse, and perhaps carrying drinking water from the pump—were all part of the job description for a teacher in a rural school.

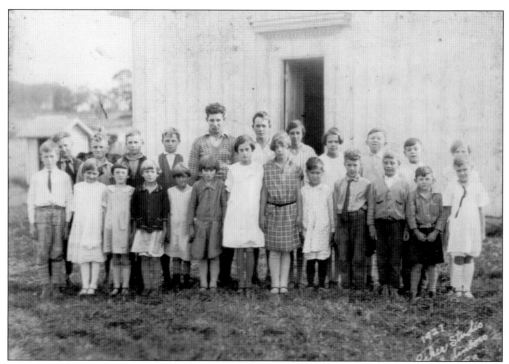

This 1927 photograph at the Bagdad School shows Gordon Marsh, Mary Czesnowski, Doris Woods, Olga Molash, Mary Loper, Beatrice Chaney, Francis Stevens, Merton May, John Molash, Mary Stevens, Alden May, Garth May, Alec Molash, Peter Molash, Beatrice Chaney, Ernest Marsh, Pearl Dinger, Anna Czesnowski, Willie Czesnowski, Arthur Stevens, and Stella Czesnowski. Several students are unidentified.

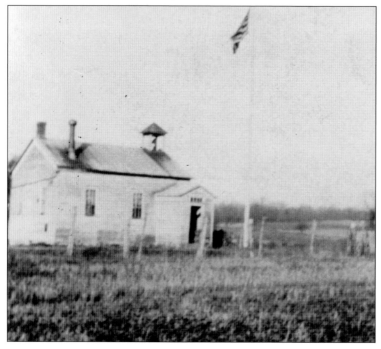

Located on West Greene Road between Donation and Strong Roads, Bonnell School was one of possibly 20 one-room schoolhouses in Waterford Township. In these small structures, one teacher usually taught pupils from first through eighth grades. Especially in the early days, this would typically be all the education the student would ever receive.

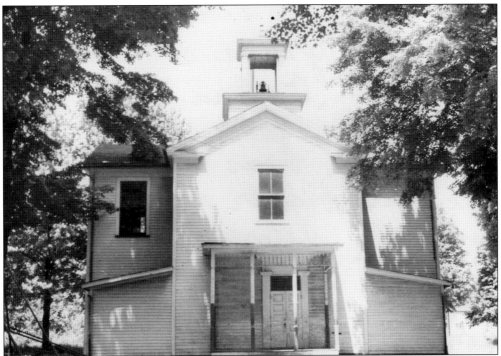

The Waterford Borough Grade School was located on East Fourth Street between Cherry and Chestnut Streets. It had three rooms, three teachers, and eight grades. The children from town attended school here, and those from outlying areas went to one-room schoolhouses. In the photograph below, the students from Room 3 pose in the spring of 1909. In 1976, after many years of service, this school was torn down. Fourth Street was closed off to make room for the newer and larger elementary, which is still in use today.

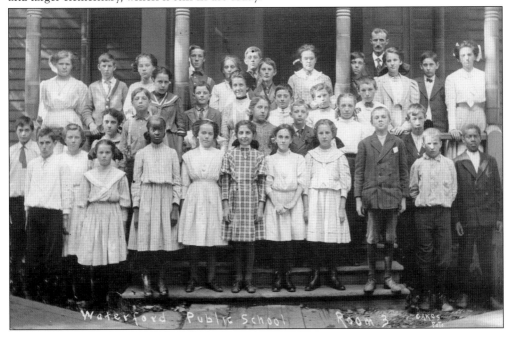

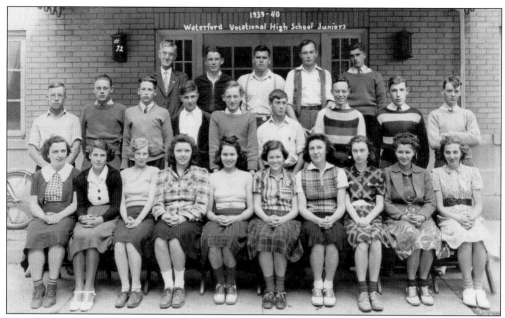

The junior class of 1939–1940 of the Waterford Vocational School poses for their photograph. From left to right are (first row) Autumn Shields, Josephine Chaffee, Maxine Chelton, Patricia Worster, Barbara Lamberton, Annette Rice, Edna Nye, Dorothy Bolkey, Martha Oblinski, and Pauline Dorman; (second row) Calvin Preston, John Hailwood, Victor Turner, Lloyd Kerr, Matthew Rutkowski, William Beaumont, Dana Phelps, James Donnell, and Dick Schlosser; (third row) T.G. Shallenburger (teacher), Nelson Fairchild, Blaine Wilcox, Ted Grossholz, and Howard Proctor.

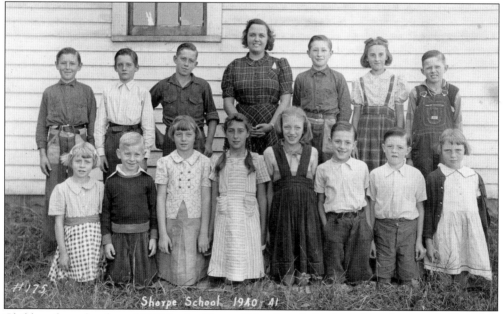

Children from the class of 1940 in the Sharpe School smile for their class photograph. From left to right are (kneeling) Evelyn Loop, Jim Goldsmith, Inez Loop, Shirley Schwab, Leah Hoover, Robert Hoover, Merle Hoover, and Martha Lemock; (second row) Joe Hatala, Robert Holder, Carl Loop, Ann Black (teacher), John Hatala, Marjorie Proctor, and Richard Sharpe.

The first school built in Waterford was a traditional one-room log cabin schoolhouse. It was originally built where the park is but was moved to the grounds of the Waterford Academy and later to Chestnut Street between Fifth and Sixth Streets. The building is still at that location.

The Waterford Church of the Nazarene was started in June 1932 and was duly organized in October 1932 with 12 charter members. It held services in the hall over the LeBoeuf Theater on West Main Street until they rented a storeroom off the corner of East First and High Streets. They held services there until February 1, 1946, when they moved to their present site, a new church building on Cherry Street.

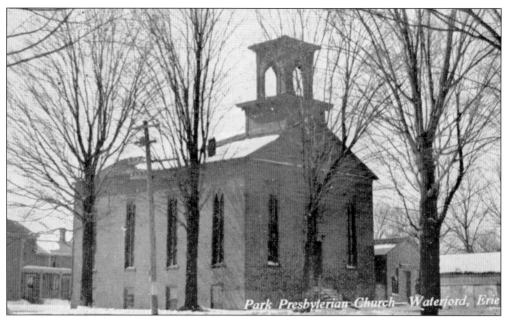

The First Presbyterian Church is sometimes called Park Presbyterian Church because of its location by the park. It was organized in 1809 with Rev. John Mathews as its first pastor and William Bracken, John Lytle, and Archibald Watson as trustees. The church building was erected in 1835 at a cost of $5,000. It was incorporated on October 6, 1866, with Reverend Bradford officiating.

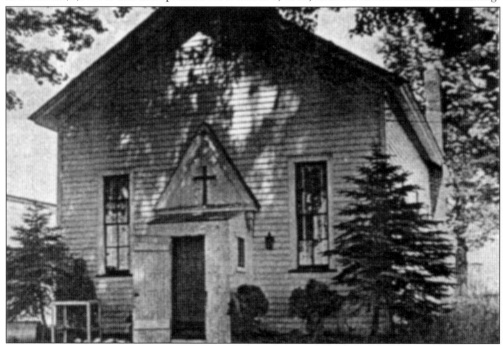

The edifice of Saint Cyprian's Church was built in 1878 on Donation Road near Depot Road. It was a mission church with priests supplied by Saint Theresa's in Union City and St. Boniface on Wattsburg Road. In 1953, services were held in their parish hall and later in the Elgin laboratory building. It was constituted a parish in 1960. The original building was torn down in 1971.

The Methodist church stood at the corner of East Fourth and Cherry Streets, where the Waterford Elementary School is now. This sanctuary burned in 1946, and the congregation moved to the United Presbyterian Church building at West Second and Walnut Streets. The Methodists had a minister and the Presbyterians had a building, so eventually they combined and became the Asbury Methodist Church.

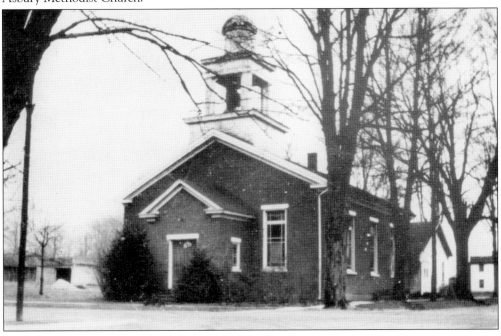

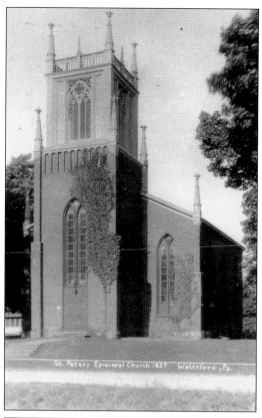

St. Peters Episcopal Church 1829 Waterford, Pa.

Saint Peter's Episcopal Church was a vital part of the early Waterford community. The congregation was organized in February 1827 and held services in the Waterford Academy. On March 28, 1831, the Reverend Bennett Glover, wardens M.B. Bradley and Timothy Judson, and vestrymen James Pollock, Martin Strong, John Tracy, Amos Judson, and John Vincent held a meeting and resolved to build a church. The cornerstone was laid in the fall of 1831, and by November 15, 1832, the church was finished and consecrated by the assistant bishop of the Diocese of Pennsylvania, H.U. Onderdonk. It is recognized as the oldest stone and brick Episcopal church west of the Allegheny Mountains and the oldest house of worship still holding regular services in Erie County.

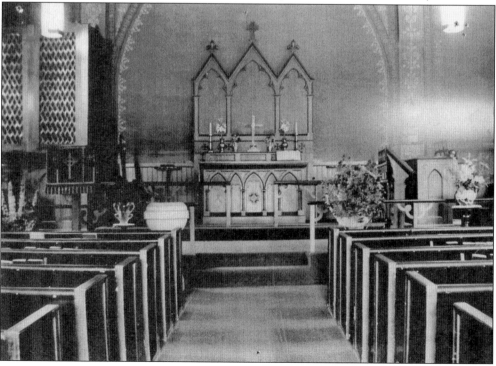

Seven

MILITARY

From the very beginning, the military has played a role—sometimes major—in the Waterford area. The site of the town first served as a French military fort and was a decisive factor in the French and Indian War. It then became a British fort and finally an American one.

During the Revolutionary War, there were probably no white men in this area; a few years later, however, land was given to those who had served, and veterans had a significant part in the development of the community. During the War of 1812, there is no record of how many men from Waterford may have served in the military, but the town was a major transfer point for materials shipped upstream from Pittsburgh to supply the fleet Admiral Perry built for the Battle of Lake Erie.

The Civil War began on April 12, 1861, and when a call for volunteers went out a few days later, 140 men from around Waterford answered the call immediately. Many more joined later. Company E of the 83rd Regiment of Pennsylvania Volunteers was recruited in Waterford, and it saw major action throughout the war.

It cannot be confirmed how many townspeople served in World War I, but from listening to old-timers in the community, it is known that the town was well represented. During World War II, this area was deeply affected. The area had representatives from the community in all branches of the military, and they served all over the world. A significant number were wounded, taken prisoner, or lost their lives. One of these brave men was 1st Lt. Warren "Bud" Ridgway, who was 22 when he was shot down over Yugoslavia in March 1944. He was the grandson of C.H. Mauer and husband of Anne Schlosser. The couple had been married less than a year when he was killed.

Since then, people from the area have been in nearly every conflict in which America has been involved. One might say Waterford is truly a community of patriots.

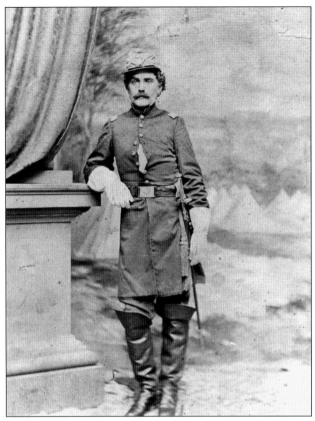

Capt. Amos Mitchell Judson was born in Waterford in August 1826. He was educated at the Waterford Academy and Yale College. In 1861, after serving three months in the Erie Regiment, he reenlisted in the 83rd Regiment, a company recruited in Waterford. During his time in the service, he was engaged in 19 battles. He would later write *The History of the 83rd Regiment Pennsylvania Volunteers*, a detailed history of the war.

The 3rd Brigade was made up of the 17th New York, the 16th Michigan, the 44th New York, and the 83rd Pennsylvania. Colonel Hayes, later General Hayes, took command of the brigade around November 20, 1861. Officers of the 3rd Brigade are, from left to right, unidentified, Captain Nash, Lieutenant Newell, Captain Ball, Captain Judson, Colonel Hayes, and Lieutenant Clark.

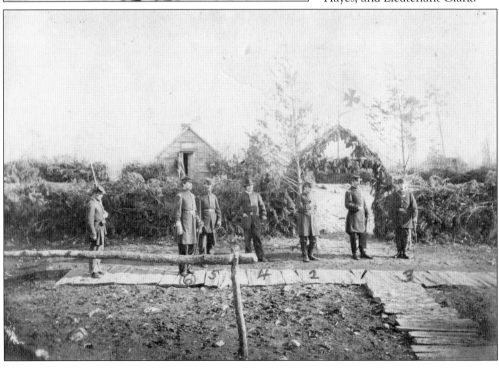

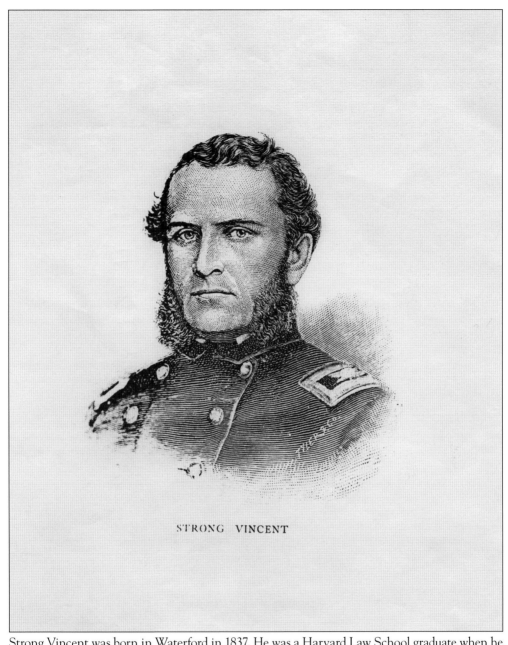

STRONG VINCENT

Strong Vincent was born in Waterford in 1837. He was a Harvard Law School graduate when he joined the 83rd Regiment as it was formed at the beginning of the Civil War. Upon the death of regimental commander Col. John McLane in June 1862, Vincent was elected to take his place and promoted to colonel. In May 1863, he assumed command of the 3rd Brigade, which consisted of four regiments, including his own, the 83rd Pennsylvania. He became a hero for inspiring his troops in the fighting at Little Round Top in the Battle of Gettysburg but was mortally wounded in that battle. Abraham Lincoln appointed him brigadier general on July 10, 1863. Sadly, the president did not know that he had died three days earlier, on July 7. At the time of his death, he was just a few days past his 26th birthday. His boyhood home was a Waterford landmark until it burned around 2000.

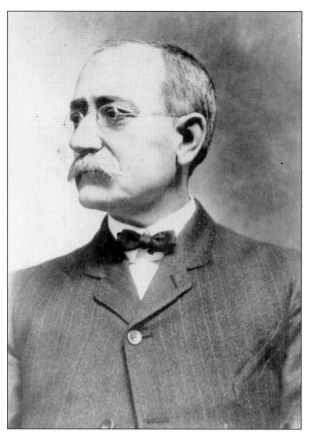

Horace Hovis was 13 years old when he enlisted as a drummer boy in the 111th Pennsylvania Volunteers. At the time, he was the youngest recruit. In 1863, he was hurt and sent to a Union hospital, then was discharged due to his injuries. Once recovered, he reenlisted later that year and marched with Sherman to the sea. He was honorably discharged in June 1865 after he marched in the Washington, DC, Grand Parade Review.

During the Civil War, Waterford was the designated recruitment center for the surrounding area. The recruitment center, located on the east side of Main Street between South Park and East Second Streets, was home to the Pennsylvania 83rd Regiment. According to Amos M. Judson's book about the history of the 83rd Regiment, 122 men enlisted into Company E alone, and that did not count some who later deserted.

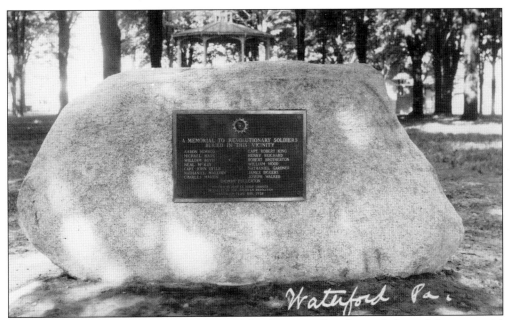

The Fort LeBoeuf chapter of the Daughters of the American Revolution dedicated this memorial on Flag Day 1928 to the Revolutionary soldiers buried in the Waterford area. The soldiers listed are Aaron Himrod, Michael Hare, William Boyd, Neal McKay, Capt. John Lytle, Nathaniel Mallory, Charles Martin, Capt. Robert King, Henry Reichard, Robert Brotherton, William Hood, Nathaniel Gardner, James Biggers, Joseph Walker, and Thomas Fullerton.

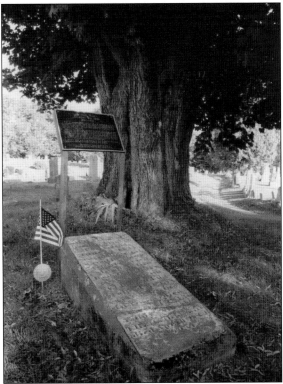

Michael Hare was truly a character in local history. It is not known if all this is true, but on his gravestone in the Waterford Cemetery is written, "Michael Hare, born in Armagh County, Ireland, June 10, 1727, was in the French War at Braddock's defeat, served through the Revolutionary War, was with St. Clair and was scalped at his defeat by the Indians. Died March 3, 1843 AE 115 years, 8 months, 13 days. Elizabeth, his wife died March 3, 1813 AE 90 years."

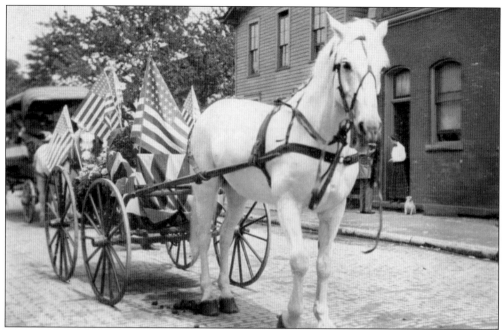

Col. W.O. Colt captured Frank, the famous old warhorse, during the Civil War. After the war, Colonel Colt rode Frank back to Waterford, where he roamed the town freely. At the age of 35, he was leading the 1887 Fourth of July parade when he died of excitement after a cannon was fired. He was buried in the ball diamond, standing up, with full military honors.

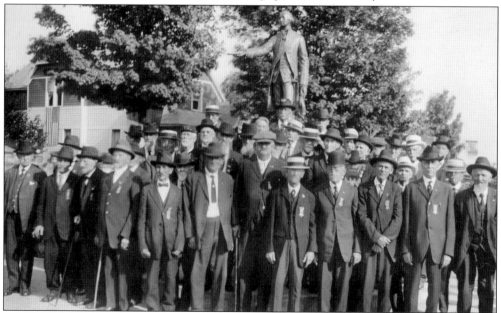

The Grand Army of the Republic Post No. 67 was founded in 1866 and limited to honorably discharged veterans of the Union army, navy, marines, or revenue cutter service, who had served in the Civil War. In 1890, there were 409,489 members. They held their final "encampment" in 1949, and the last member died in 1956 at the age of 109. A reunion of the members was held at the dedication of the George Washington statue in 1922. (Courtesy of Anita Palmer.)

Above is the World War II Roll of Honor for Waterford Borough and Waterford Township, and below is the one for Mill Village Borough and LeBoeuf Township; both occupied a place of honor in each community. The one for Waterford was prominently displayed on the northeast corner of the park facing Main Street. It could be seen by anyone walking through the park or driving by. The other one was in Mill Village at the southeast corner of Route 6 North and South Main Street. There were over 400 names on the two rolls—a very large percentage of people from a community of no more than 7,000.

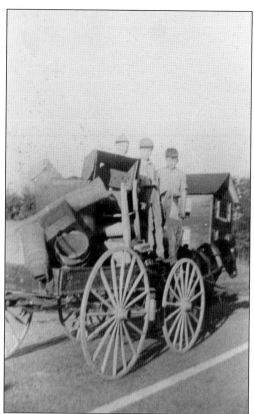

Young Marshall, Ronald McCall, and Red Shields are out in the 1940s with their horse-drawn cart doing their patriotic duty of collecting scrap metal to be taken to Erie for processing. The scrap metal would eventually be used for supplies during World War II. Knowing every citizen was asked to do their part in supporting the troops, this was an ingenious way these young people could help.

The United War-Work Campaign, organized by request of Pres. Woodrow Wilson, brought together seven organizations—the YMCA, the YWCA, the American Library Association, the War Camp Community Service, National Catholic War Council, the Jewish Welfare Board, and the Salvation Army. Charged with raising over $170 million for the war in 1918, they all worked together during one large funding drive to provide for the troops as they returned home from the war and transitioned back into civilian life.

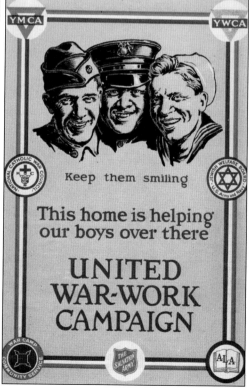

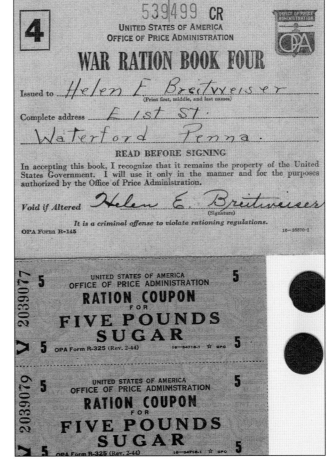

NOTICE OF CLASSIFICATION App. not Req.

Robert Alvin Davis
(First name) (Middle name) (Last name)

Order No. 699 has been classified in Class 2-B

(Until _____, 19_____)
(Insert date for Class II-A and II-B only)

by ☒ Local Board.
☐ Board of Appeal (by vote of _____ to _____).
☐ President.

JAN 6 '44 Michael D. Lombard
(Date of mailing) (Member of local board)

The law requires you, subject to heavy penalty for violation, to have this notice, in addition to your Registration Certificate (Form 2), in your personal possession at all times—to exhibit it upon request to authorized officials—to surrender it, upon entering the armed forces, to your commanding officer.
DSS Form 57. (Rev. 3-29-43)

During World War II, all men, upon reaching the age of 18, had to register with their local draft board to see if they would be eligible to be drafted into military service. After providing the draft board with pertinent information concerning health, occupation, and other facts, they would receive their status. 1-A would mean they could be called to service first. Robert Davis was classified 2-B. (Courtesy of Linda Falconer.)

During World War II, there was a shortage of many commodities, such as gasoline, meat, and sugar. In order to purchase these items, one had to apply to the Ration Board, who would decide if one qualified for ration stamps. The stamps would be issued to the head of the household or business and were not transferable. The Office of Price Administration (OPA) tokens were given in change if the stamp holder bought less than the amount on the ration stamp. (Courtesy of Anita Palmer.)

539499 CR
UNITED STATES OF AMERICA
OFFICE OF PRICE ADMINISTRATION

WAR RATION BOOK FOUR

Issued to Helen F. Breitweiser
(Print first, middle, and last names)

Complete address E 1st St.
Waterford Penna.

READ BEFORE SIGNING

In accepting this book, I recognize that it remains the property of the United States Government. I will use it only in the manner and for the purposes authorized by the Office of Price Administration.

Void if Altered Helen E. Breitweiser
(Signature)

It is a criminal offense to violate rationing regulations.
OPA Form R-145

UNITED STATES OF AMERICA
OFFICE OF PRICE ADMINISTRATION
RATION COUPON
FOR
FIVE POUNDS SUGAR
OPA Form R-325 (Rev. 2-44)

UNITED STATES OF AMERICA
OFFICE OF PRICE ADMINISTRATION
RATION COUPON
FOR
FIVE POUNDS SUGAR
OPA Form R-325 (Rev. 2-44)

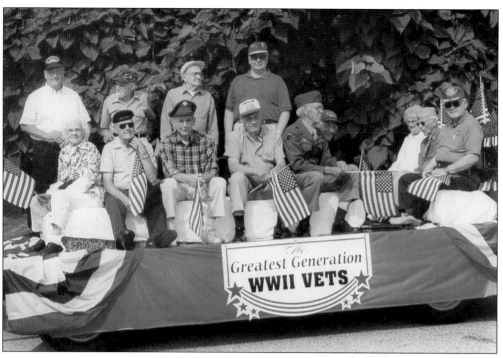

Waterford salutes its "greatest generation." World War II veterans ride on the Fort LeBoeuf Historical Society's float in the Waterford Heritage Days Parade. They are, from left to right, (seated) Rose Skwaryk Malinowski, Karl Gaber, Bob Laughlin, Dick Jenkins, Ken Anderson, Carm Bonito, Emmalynn Chapman, Jack Taylor, and Earl Stubbe; (standing) Robert Jenkins, Jack Holzer, Morrell Pratt, and Don Schmitt.

Lt. J.G. Alan Ramsey Harper of LeBoeuf Township was one of the first residents of the Waterford area to be killed in World War II. He was assistant principal and athletic director at McKean High School when he enlisted in the Navy in 1942. He was killed in action in June 1943 at age 32. He was the husband of Elizabeth Pollock, whose family was among the first settlers in LeBoeuf Township.

The Navy drafted Karl C. Gaber, MMC 2C, in 1943 during World War II. Karl received training in radar operations, gunnery, and squadron operations. He was assigned as top turret gunner on a Navy plane that was shot down by the Japanese Navy in Toyko Bay in August 1945. He was captured, incarcerated, and tortured in the Ofuna Prison Camp for a month. He received his discharge from the Navy from Great Lakes Separation Center in April 1946.

Neil Bartholme, another Waterford resident, became a World War II pilot. On May 26, 1944, while on his 38th mission to bomb a German air base, Neil's B-26 Marauder was shot down over Chartes, France. Neil parachuted into a cornfield, was captured, and held as a prisoner of war at Stalag Luft 1. He was liberated in May 1945. Neil retired from active reserve with the rank of lieutenant colonel.

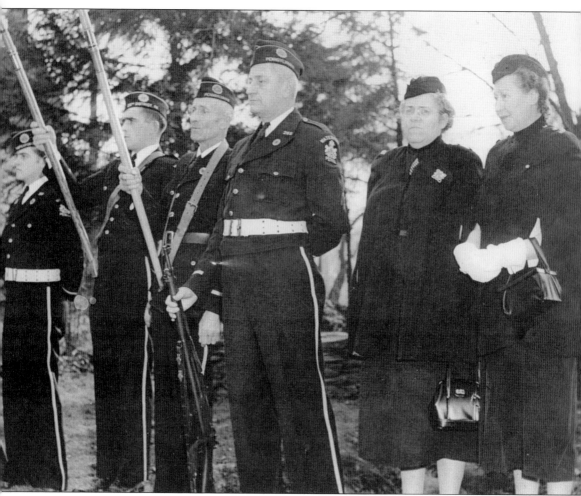

Members of the American Legion Post No. 285 are pictured participating in a service conducted at the statue of George Washington in 1952. Members of the Color Guard are, from left to right, Lawrence Sherwood, Howard Proctor, Mark Hilliker, and Morris Hilliker. Representing the American Legion Auxiliary are Blanche Hilliker and Dorothy Hilliker.

Eight

RECREATION

Lake LeBoeuf has always provided recreation for people in the area. One might even imagine George Washington trying his hand at fishing while waiting for a reply to the message he had delivered to the French.

The small lake was formed when the Wisconsin Glacier receded between 10,000 and 15,000 years ago. It is about two-thirds of a mile long and one-half mile wide with a small island in the center.

Hunting and fishing have always been popular in the area, and in early times, it was a means of survival. But when transportation into the area improved and people had more leisure time, the abundance of fish and game and the charm of the lake began to attract vacationers from throughout the region. Other attractions were developed to cater to the needs of the visitors.

Several hotels were built or expanded. There were boat and cottage rentals, camping sites, and bathing beaches. LeBoeuf Park, a complex with a skating rink, dance hall, and an amusement park, was built on the shores of the lake. Adjacent to that was a nightclub, the Show Boat, and not far away, there was a small zoo that displayed native animals.

Waterford reached its heyday as a tourist area in the 1930s and 1940s, but over time, tastes changed, and the area no longer held the attraction it once did. The zoo, amusement park, skating rink, and many of the other attractions are gone. It is quiet around the lake now, but the beauty still remains. And the fishing is still good!

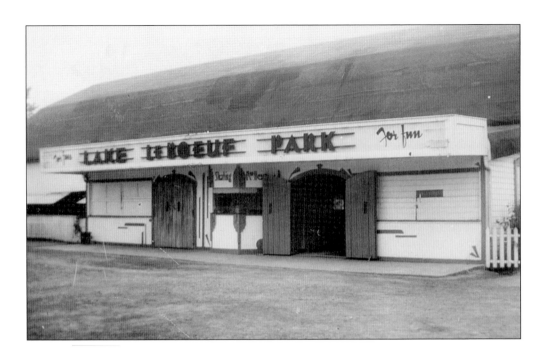

Edward Hopkins established Lake LeBoeuf Park, a small amusement park near the outlet of Lake LeBoeuf. It was located just south of Waterford Borough off Route 19. There was a penny arcade, a refreshment stand, and a main building with other concessions, pictured here. It originally was a dance pavilion and was a popular gathering place in the 1940s and 1950s. Behind the dance hall was a bathhouse (the out-building on the left in the photograph below) and the beach. Edward Hopkins later converted the dance hall into the LeBoeuf Skating Rink. The skating rink was sold to John Clark in the 1960s, and he had a furniture store there until it burned in the 1970s.

THE SHOW BOAT — RD. 5 — WATERFORD, PA.

The Show Boat was located on Route 19 on the shores of Lake LeBoeuf, adjoining the Lake LeBoeuf Amusement Park. Owned by local entrepreneur Eddie Hopkins, the club was decorated with a nautical theme. It was the place to go for wining, dining, and dancing in the 1930s and 1940s. It was a dance hall and recreational center that attracted people from as far away as Pittsburgh. It is now the Showboat Apartment Complex.

Some of the "Jolly Pittsburgh Crowd" girls pose for a photographic moment in front of the bathhouse at Lake LeBoeuf Park. The "Jolly Pittsburgh Crowd" was a group of girls and women who traveled from Pittsburgh to vacation at Lake LeBoeuf every summer.

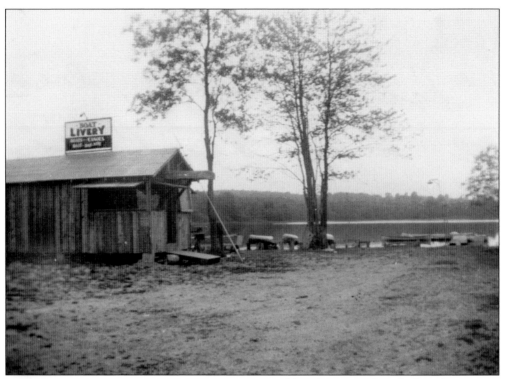

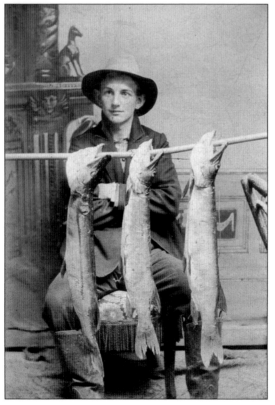

Chet Comer, a Waterford resident, owned the Boat Livery and Bait Shop. It was located in Porter Park on Lake LeBoeuf. One could rent canoes or fishing boats and get all the supplies for a leisurely day on the lake. Chet's motto was "Whip out a boat."

Muskie fishing tournaments were one of the main attractions around the Waterford and Lake LeBoeuf area. People came from all around to try to "land the big one" and walk away with the trophy. Here is Walter Schlosser, a Waterford resident, with his catch from one such tournament.

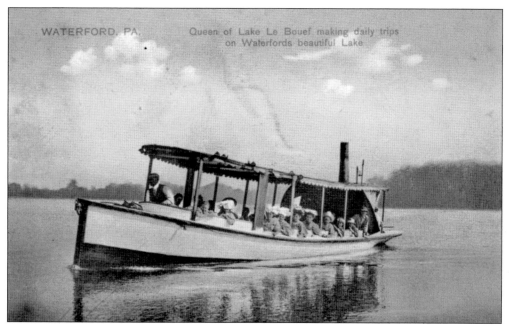

This penny postcard depicts the *Queen Belle of Lake LeBoeuf I*, one of two steam-powered boats offering daily tours of Lake LeBoeuf. For 10¢, one could take a cruise across the lake and around the island. Lee Lindsley, owner and captain of the *Queen Belle*, built the boats. The second *Belle* was built after the first sank.

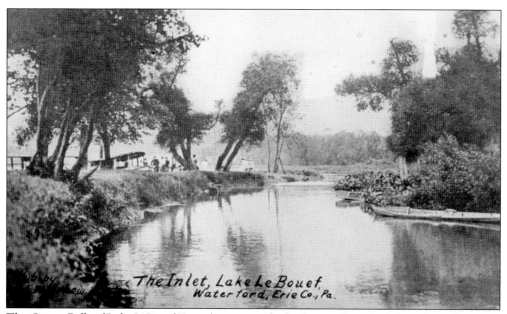

The Inlet, Lake Le Bouef,
Waterford, Erie Co., Pa.

The *Queen Belle of Lake LeBoeuf II* can be seen in the background on the left in this picturesque scene of the inlet to Lake LeBoeuf. A crowd of people is waiting to board the boat and embark on a trip around the lake. The *Belle II* caught fire much later and also sank. Both boats are still resting on the bottom of the lake.

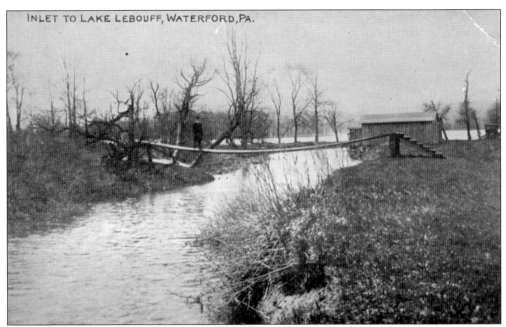

INLET TO LAKE LEBOUFF, WATERFORD, PA.

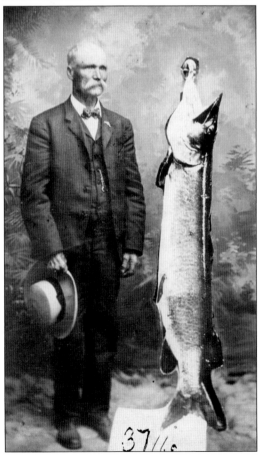

Lee Lindsley, with the help of his son Charley, built the original suspension bridge that crossed the inlet to Lake LeBoeuf, thus providing access for foot traffic to Porter Park. Porter Park was named after Waterford resident Noah Porter, who donated the land to Waterford Borough.

Noah Porter owned the farmland adjacent to Lake LeBoeuf. He donated a portion of this property to the Borough of Waterford in order to provide public access to the lake. The borough honored him by naming the property Porter Park. Noah is shown in this photograph with his prize 37-pound muskie that was caught during a fishing tournament at the lake in July 1905. (Courtesy of Anita Palmer.)

Muskie tournaments were the highlight of the summer season. Fishermen from all over the tristate area flooded into Waterford to cast their lines into Lake LeBoeuf. G. Bert Skiff (left), with Taylor Stranahan (center) and Horace Hare (right), shows off the 39-pound prize they caught in June 1900.

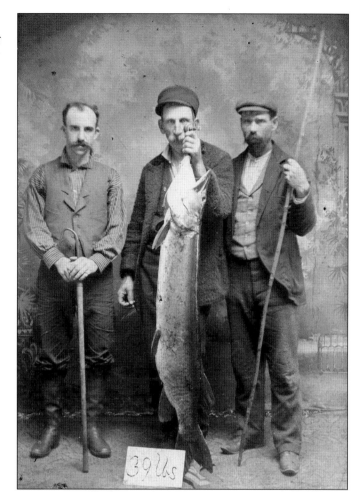

W.E. Briggs caught three muskies within eight hours of fishing on Lake LeBoeuf in August 1917. The house in the background, located on the corner of Second and Walnut Streets, is now a laundromat.

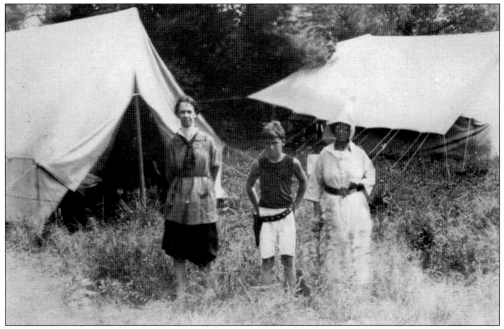

In 1918, with the men of the family serving in World War I, 12-year-old Byron Bowen was the protector of the camp. He carried a revolver with him at all times to protect the women from any danger. Pictured on the left is his mother, Agnes Bowen, and on the right is his aunt Jennie Thompson.

For several years, the Bowen family and friends camped just north of the outlet on the hill across the road from Lake LeBoeuf (now the site of Erie Truck and Trailer Sales). Pictured from left to right in 1914 are Amanda Bowen, Don Bowen, Agnes Bowen, Fred Near, Amy Mansfield, Bill Mansfield, C. W. (Charlie) Bowen, and Byron Bowen.

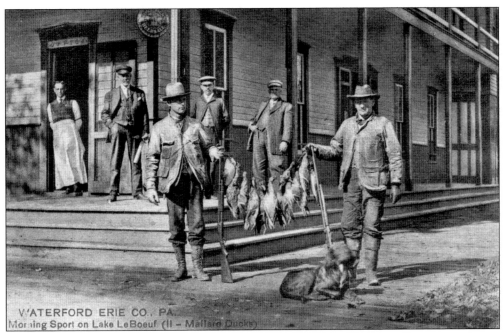

WATERFORD ERIE CO., PA.
Morning Sport on Lake LeBoeuf (11 - Mallard Ducks)

On a 1908 picture postcard, hunters in front of the Park House proudly display their day's quota of mallards. Fishing on Lake LeBoeuf and hunting in adjoining woods and farmlands was extremely popular with locals and visitors alike. These sports brought a considerable amount of business to the hotels and restaurants in the area and are still popular today.

Wallace McCall Sr., an avid sportsman and hunter in his day, shows off the buck he shot on his property off Seroka Road and Route 19 in Waterford Township. The earliest settlers of this region looked at hunting as a necessary part of their sustenance. Today, it continues to be a popular activity among sportsmen and sportswomen of all ages.

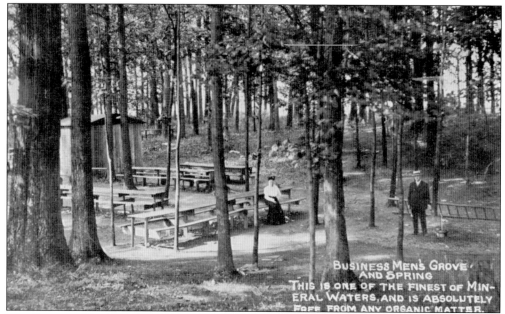

The Business Men's Grove and Springs was located between Cherry and Chestnut Streets, north of East Sixth Street. It was a popular site in the summertime for all sorts of gatherings and picnics. Horace Hovis and his sister are pictured here at one such gathering. It was noted for its delicious mineral spring water, considered by many to be a great benefit to the health of those who would partake of it.

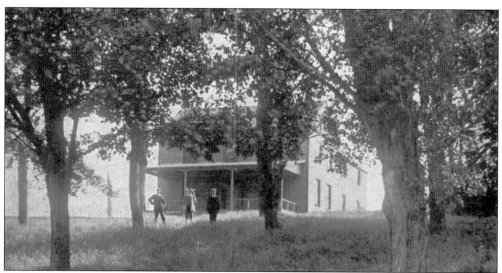

The Waterford Business Men's Association Club House was located on Route 19 South near the borderline between Waterford Borough and Township. This photograph was taken in 1913. The Waterford Business Men's Association continued to use the club until the late 1930s, when it was eventually sold. It was owned in the 1940s by Edward Hopkins, who also owned the LeBoeuf Park.

Andrew Ellicott laid out the park in 1795, the same year he laid out the town of Waterford. He later used the same plan to lay out the city of Erie, with north and south streets names for trees and east and west streets being numbered. The bandstand was built in 1876 and stood near the highway. It was later moved to the center of the park. In 1977, it was rebuilt by the Fort LeBoeuf Historical Society and stood for almost 25 years. The Borough of Waterford decided to rebuild it once again using more modern materials. Robert Cook planted the trees, which now shade the west park, in the early 1800s.

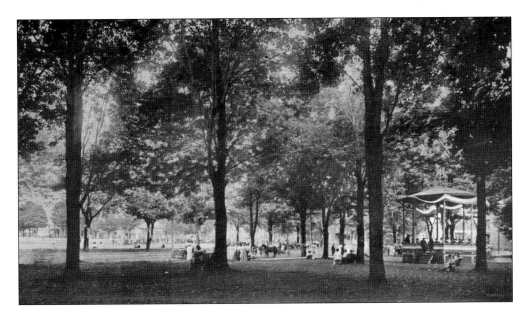

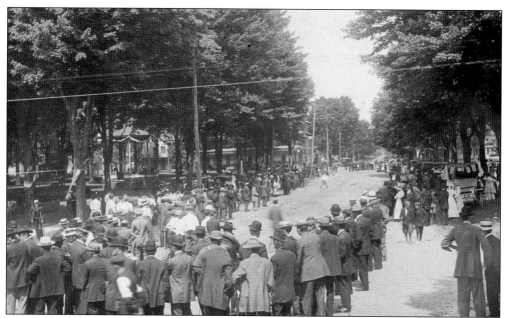

The 1909 Waterford Old Home Week was a festive occasion. The park was the hub of most activities. There were concerts, speeches, and other acts performing in the decorated bandstand in the west park. In the east park, there were ball games, races, and other games for children.

A.J. Farrar built the house located on High Street. His daughter Mary Viola Farrar, who later married Charles W. Capell, inherited the house when her parents passed away. The family is celebrating the 1909 Homecoming Day from their front porch. Other owners were A.P. Shaw, the Chelton family, the Lehenthalers, Cecil Hull, the Freemans, and the Andersons. Michael and Suzanne Baum now own it.

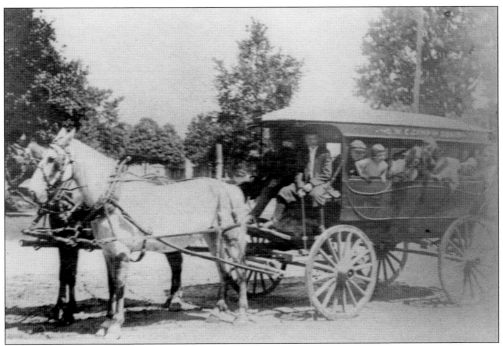

A wagonload of excited young people take a summertime joyride around town on the W.C. Camp and Son dray line between its excursions to and from the railroad station at the depot east of Waterford.

Lena Rice is out for a drive with her horse and buggy, the typical mode of transportation before the automobile. The Jim Rice farm was located west of Waterford on Sedgwick Road at the intersection with Trask Road.

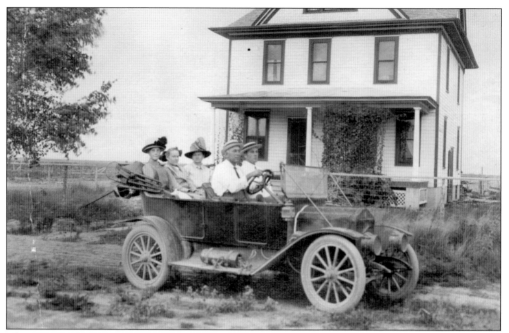

This group of Waterford residents is taking advantage of the nice weather for a Sunday drive in their automobile. There were few paved streets in Waterford until the late 1930s, so it was a rough ride most of the time.

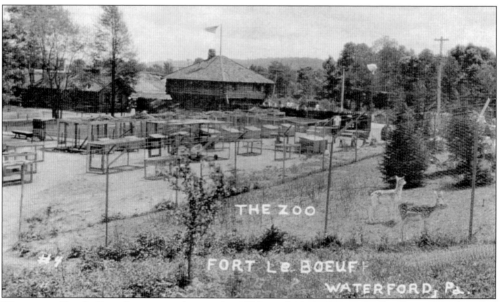

THE ZOO

FORT Le BOEUF

WATERFORD, PA.

The zoo at Fort LeBoeuf was open during the 1930s and 1940s. It was south of Waterford, at the intersection of Routes 19 and 97, and north of the restaurant operated by the Boarts. Since it was a Pennzoil gas station, the locals called it the Pennzoil Zoo. They had a bear, some deer, and other smaller animals. They closed after the bear injured a visitor.

Nine

NEIGHBORING AREA HISTORY

Waterford was one of 16 original townships in the county, with roughly the same boundaries that exist today. A small portion was taken from Waterford Township in 1854 when Summit Township was formed. Summit is the second youngest and the second smallest township in Erie County, Pennsylvania. It was founded in 1854 out of the western part of Greene, the eastern part of McKean, and a small section from the northern part of Waterford Township. Today, it is the retail hub for Erie County with shopping plazas, theaters, hotels, and a casino.

One of the largest towns was Mill Village, located in the center of LeBoeuf Township. Originally there were three mills, a cooper shop, a blacksmith shop, and a few houses. Nearby was a post office called Oak Grove. In the late 1850s, the Atlantic & Great Western Railroad was built through the area, and they erected a depot there, which was called Mill Village Station. It rapidly became a bustling town with over 40 shops, a hotel, two churches, and a newspaper. In 1860, it was incorporated as Mill Village Borough. In 1924, a devastating fire leveled most of the town and little of the downtown area was ever rebuilt. About all that remains today are a couple of brick or block buildings that survived the fire, a school, two churches, a post office, a bar, and some pleasant houses, most of which were built after the fire.

There were other hamlets around Waterford that once flourished then declined, leaving perhaps a small church, a deserted store, and a few houses. They had names like Edenville, Sharpe's Corners, Wheelertown, Sibleyville, New Ireland, Phelps Corners, and Manrosstown. They were once area landmarks; now they are forgotten by nearly everyone, except those few who are interested in what once was.

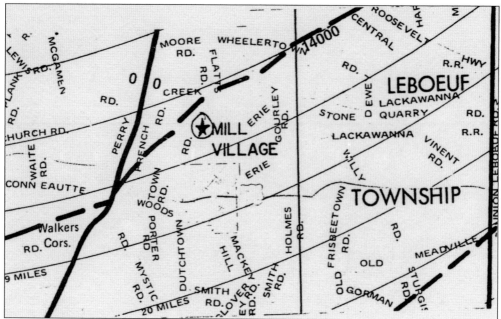

LeBoeuf Township received its name from LeBoeuf Creek, which joins French Creek within its limits. It is one of the original townships in Erie County. It is bounded on the north by Waterford Township, on the east by Union Township, on the west by Washington Township, and on the south by Crawford County. Mill Village Borough is nearly in the center of the township, about a mile from French Creek.

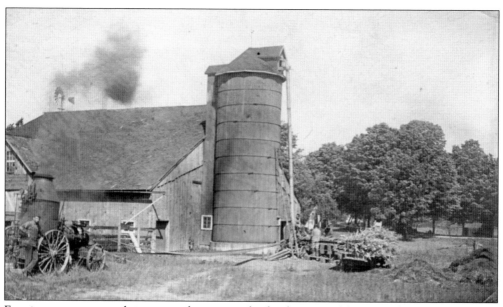

Farming was an extremely important business in the development of the area. This 1914 photograph shows farmers in LeBoeuf Township filling a silo with corn fodder. The cut fodder becomes compressed in the silo and ferments, preserving it for winter cattle feed. Note the steam tractor being used as a power source.

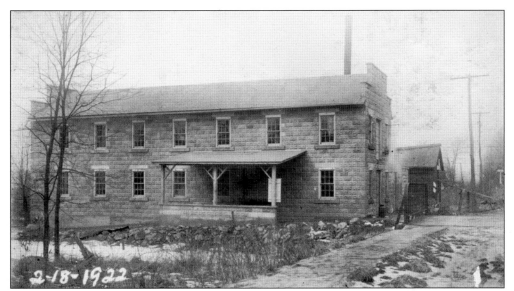

The cheese factory in Mill Village, pictured in 1922, was for many years run by the Kerr family. A delicious cheddar-type cheese was made here. It came in cheesecloth-lined, round wooden boxes, perhaps 18 inches in diameter and nine or 10 inches high. Bringing their milk to the cheese factory provided a good source of income for many area farmers. The building, which is still standing, has been converted into apartments.

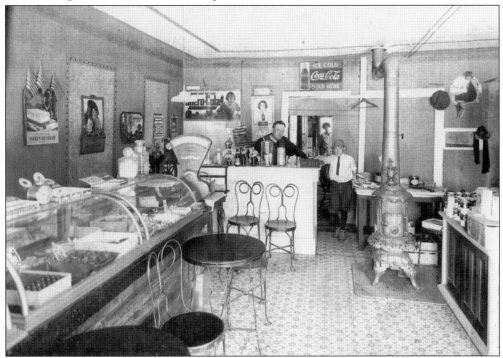

Shields Store in Mill Village was located on Main Street. It was owned and operated by the Shields family, Homer, Florence, and Marshall, in 1925. It appeared to be a combination grocery, candy, and soda shop. Advertisements on the wall are for Moore's Ice Cream, Coca-Cola, and Cvero Cola. On the counter are cigars for the gentlemen.

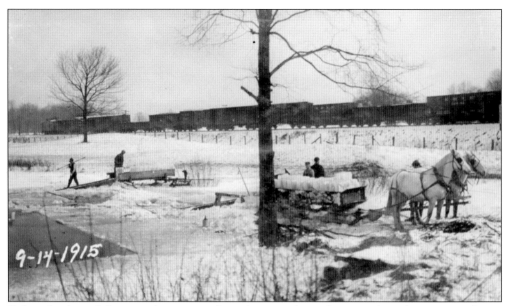

Before the days of electric refrigeration, the only way to keep things cool was by using ice. It was cut on lakes and ponds during the winter and stored in sawdust-insulated warehouses. It kept for a surprisingly long time. Pictured in 1915 is a crew harvesting ice near Mill Village. In warm weather, the iceman would deliver blocks of ice to homes and businesses every few days.

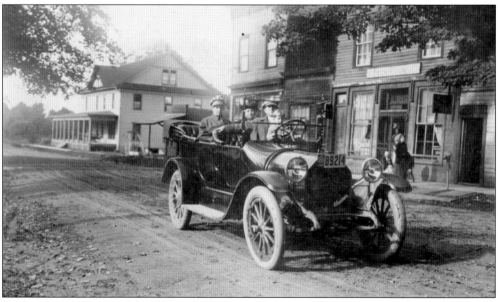

By the second decade of the 20th century, automobiles were becoming more commonplace. In late May 1915, the George Welker family proudly shows off their new Studebaker automobile in Mill Village. The small boy sitting on his father's lap seems to be the chauffeur. The Hotel Wellington is in the background.

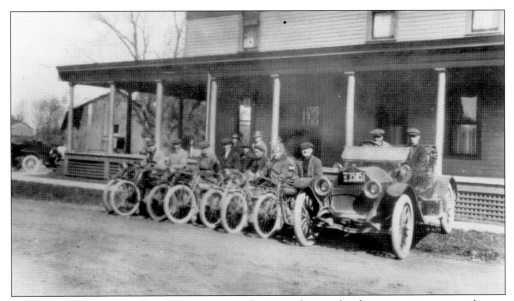

About the time automobiles became commonplace, another mode of transportation, appealing to the daredevil, became popular. In 1919, eight motorcycles line up in front of the Hotel Wellington in Mill Village. They appear ready to start on a cross-country trip, the car apparently going along to carry tools and spare parts.

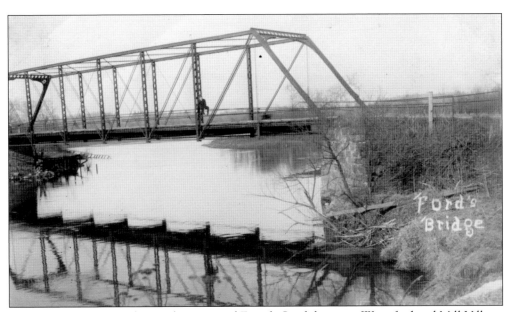

Ford's Bridge in LeBoeuf Township spanned French Creek between Waterford and Mill Village. When this photograph was taken in 1915, and for many years afterward, it had a spindly steel frame and a loose wooden deck that rattled loudly when traffic crossed it. On warm summer nights when their windows were open, people from miles away could hear every vehicle that passed over it.

Mill Village Borough and LeBoeuf Township recorded having three one-room schoolhouses in the early 1820s and 12 of them by the 1860s. In 1942, the one-room schoolhouses were consolidated into one school in Mill Village, pictured here. There were eight grades in six rooms. For the first time, children were bussed to school. After the eighth grade, the children were bussed to either Waterford or Edinboro for high school.

In the early days, Mill Village had a high school, but it was only for students in ninth or 10th grade. Upon graduation, they would continue their education in Union City, Edinboro, or Waterford high schools. The only person identified in this 1929 photograph of the graduating class is Lillian Burger (Wells), second row, third from left.

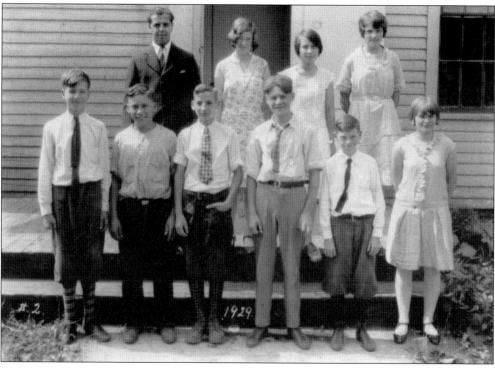

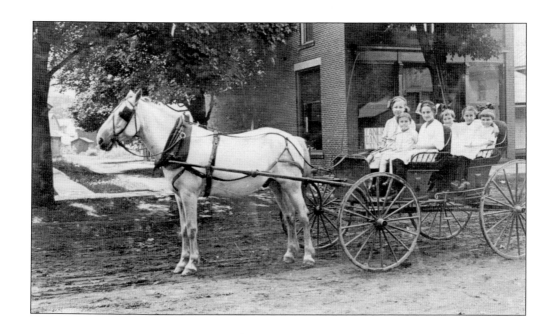

In the late-19th and early-20th centuries, travel for both business and pleasure was mostly by horse-drawn wagons and carriages. There were few paved roads or streets, even in town, and in bad weather, getting around could be extremely difficult. In the winter, snow might cover the roads for weeks, and during the spring thaw or in rainy spells, the mud could be two feet deep. In dry weather, clouds of dust could cover everything in sight. Under good conditions, this kind of travel could be very pleasant. As the photograph above shows, an unidentified Mill Village family is about to embark on a summer excursion. Below, Boyd Arters, a LeBoeuf Township farmer, is hauling calves to market in Mill Village.

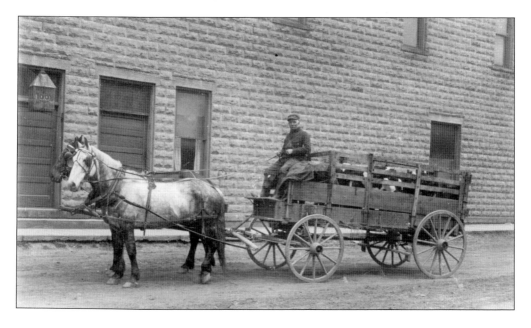

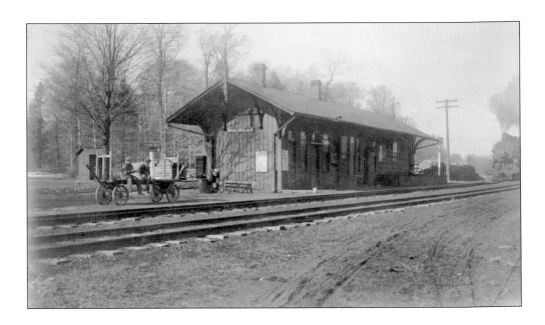

The depot in Mill Village was erected around 1860 to service the Atlantic & Great Western Railroad, which traveled from Corry through Mill Village and on to Meadville. Business began to thrive with the arrival of the railroad, adding a stave mill, a cider and jelly mill, a cheese factory, a steam sawmill, three blacksmith shops, a wagon shop, and a shoe shop. It also had a drugstore, several grocery and general stores, a hardware store, a millinery store, a jewelry store, and a "portable photograph car." There was a hotel that kept on the "temperance plan," a building housing a school and the town hall, two churches, and a newspaper. The above photograph shows the original train station. The photograph below is thought to be a railroad car used as a train station after the fire in 1924.

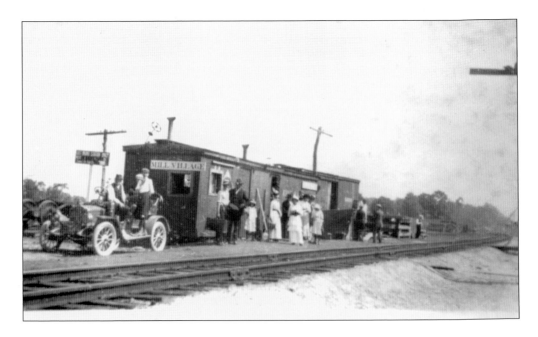

Ten

ODDS AND ENDS

Every town has items worthy of noting, and Waterford is no different. After going through the exercise of collecting photographs for this book and deciding which images should go in which chapter, it was discovered that not all of the images could be easily categorized. They are, however, important in embodying the way of life in early Waterford history, and should not be disregarded.

From stereoscopic images that once entertained visitors relaxing around the fireplace, to a dog-powered treadmill, it is this type of ingenuity that built America and made it the country it is today.

The legend of the Sentinel Tree, on Washington Mound behind the grocery store off Route 19, has been handed down for generations. It is well known by tourists and visitors as part of the heritage of Waterford. Supposedly, George Washington climbed the tree and cut off the top to see into the French fort in 1753. When it toppled in 1983, studies showed it to be about 400 years old.

This is an early photograph of the Waterford Cemetery as viewed from East Third and East Streets. The fence is no longer there, and the trees have grown immensely. The original cemetery was on the west side of Second Street but was abandoned sometime after 1865. Stones from this cemetery were moved to a commemorative site in the Waterford Cemetery on the southwestern side around 1930. A DAR plaque dedicates the site.

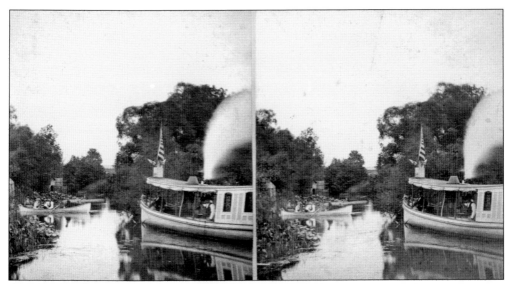

At one time, the stereoscope and view cards were found in many American homes. From 1850 until World War I, the stereoscope allowed people to visit every corner of America and the world. A stereoscopic slide has two separate images printed side-by-side. When viewed with a stereoscope viewer, the image becomes 3D. This slide, created by Stereoscopic Views of Waterford and Vicinity, is entitled *View of Mouth of LeBoeuf* by Joseph McGandy.

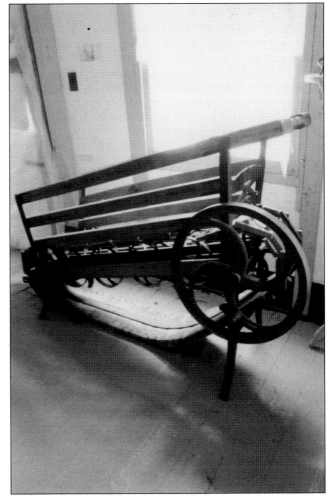

The dog treadmill is a good example of early American ingenuity and inventiveness. A belt was attached between the wheel and a machine. The dog ran on the treadmill and powered a corn grinder, butter churn, or other machine that required manual labor. It also kept the dog in good shape. The question is: How did they get the dog to run?

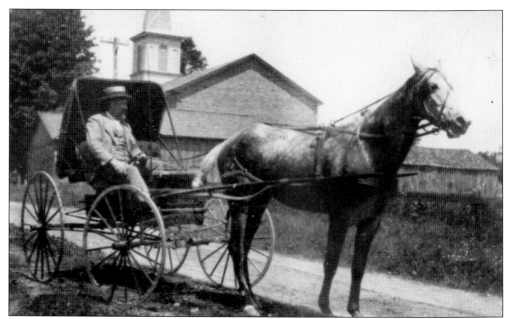

A fine gentleman rides home from church in his horse and carriage one Sunday morning after the conclusion of church services. This means of transportation was quite common until the advent of the automobile. Even then, most people in rural areas chose the horse and buggy as a more reliable and comfortable ride. After paved roads entered the scene, the carriage became more of a recreational form of transportation.

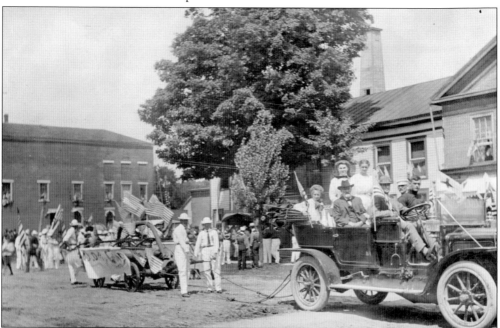

Waterford was known for its many parades. In this Memorial Day Parade, probably in the early 1900s, members of the fire company stand by their gaily decorated hand pumper in front of the borough building, as a car filled with dignitaries gets ready to pull it. The Masonic building is visible behind them, to the left.

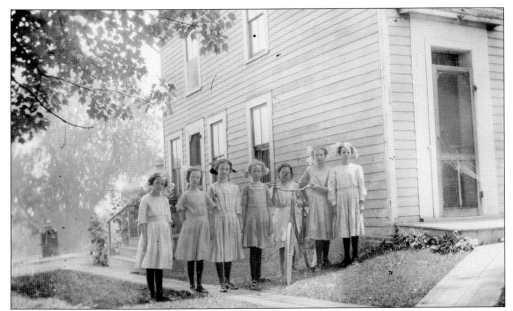

Eleanor Wishart and a group of her friends take time out to show off the new bicycle in front of her house on West First Street in 1911. The girls are, from left to right, Margaret Hawthorn, Eleanor Wishart, Elizabeth Saeger, Marie Houghton, Marjorie McKay, and two unidentified girls. All of these girls were from families that were very important in business and civic organizations.

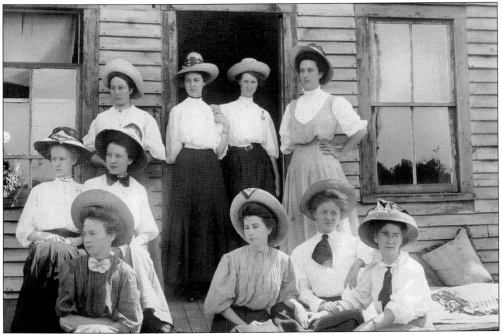

A group of ladies are caught dressed in their fineries in 1900, possibly awaiting the arrival of a train at the Waterford Depot. From left to right are (first row) Abby Wade, Nellie (Hunter) Holmes, Luella (Benson) Moore, and Rena (Trask) Mahan; (second row) Mary (Avery) Taylor and Ethel Fair; (standing) Florence (Scott) Marsters, Barbara Brace, Carrie Brace, and an unidentified woman.

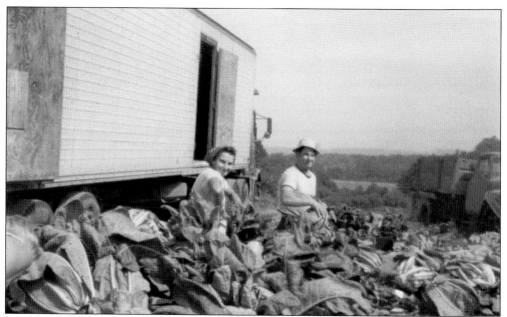

Starting in the late 1940s, Willy Czesnowsk had a large truck farming business on Bagdad Road in Waterford Township. His sister Mary and her husband, Andy Kula, are helping Willy out by packing cauliflower to be trucked to wholesale brokers in Pittsburgh or the neighboring states of Ohio and West Virginia.

Frederick Winston Ensworth founded the Ensworth Bank as a private banking house in 1895. In 1911, it became the Ensworth National Bank, with Frederick elected president and Arthur Ensworth as cashier. When Arthur died in 1946, Earl E. Johnson became his successor. In 1949, the First National Bank of Pennsylvania took over the operation and Earl was named manager. Longtime tellers Helen Thomas and Ethel Irvin remained to assist him.

Two young ladies are dressed for their parts in a 1934 pageant. On the left, dressed as a Dutch boy, is Martha Fuller, granddaughter of one-time burgess of Waterford, James Kirk. On the right, dressed as a Dutch girl, is Alma Heard, daughter of Helen and E.L. Heard, a prominent local business owner.

Horses were the main source of transportation for many people until the invention of the motor vehicle. The severe winters of northwestern Pennsylvania posed many challenges for travelers. Cutters made getting around in heavy snow a bit easier. Tunnels had to be dug out of the snow to allow access in front of Joe McKay's General Store during one particularly snowy winter in 1910.

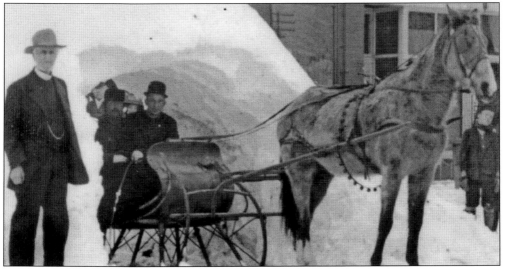

Just for fun, Mary Judson Kinnamon (left), Lucy Locke Judson (standing), and Rebecca Judson Howe (right) each removed their teeth and put on some caps that had belonged to their mother, Mrs. Pierre Judson, and posed to have their photograph taken.

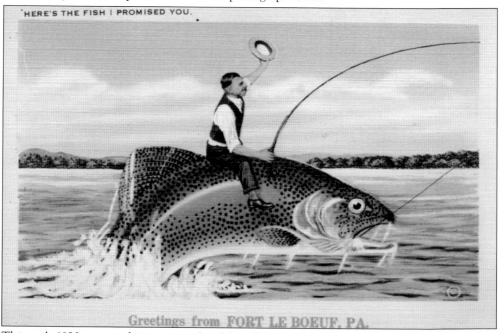

This early-1920s postcard is an example of the advertising depicting the splendor of fishing on Lake LeBoeuf. The lake is one of only two places in the world where the "Tiger Muskie," a distinct type of striped muskellunge, is found naturally. The other place is Chautauqua Lake in New York. All tiger muskies stocked by the Pennsylvania Fish Commission originated in Lake LeBoeuf.

About Fort LeBoeuf Historical Society

The Fort LeBoeuf Historical Society is a nonprofit historical society chartered under the laws of the State Department of the Commonwealth of Pennsylvania. Its purpose is to preserve and restore the historical legacy of the Fort LeBoeuf area and to familiarize the community with its heritage.

In early 1973, the historic Eagle Hotel in Waterford was for sale, and there were fears that it might be demolished. Six local citizens—Sharon and Craig Mitchell, Virginia and Daniel Kuhn, and Barbara and Richard Hakel—decided to explore the idea of purchasing the old building and restoring it. Before they could devise a plan, it was sold. They decided to form a preservation society, and under the leadership of Sharon Mitchell, in 1973 the Fort LeBoeuf Historical Society was founded.

Miraculously, the Eagle Hotel had not been torn down, and a few years later, it was offered for sale again. This time, with lots of help from others in the community, the society was able to purchase it. They acquired the property on September 9, 1977, and began the long-term preservation of the building. While they were working on parts of the building, a group of women, led by Marian Russell, held catered dinners in other rooms to raise money so restoration could continue.

The society has managed the nearby Judson House Museum since 1991, which is owned by the Pennsylvania Historical and Museum Commission (PHMC). This historic home holds additional artifacts, and some of the furnishings are original to the house. The Judson House is also the repository of the society's extensive local genealogy collection. Visitors come from all over the country seeking their family roots.

Across the road is the George Washington Memorial Park, also owned by the PHMC. The society supervises the maintenance of these facilities and conducts tours for the education of the public and to raise awareness of the rich local history.

To learn more about the society, visit www.fortleboeufhistoricalsociety.org or write to Fort LeBoeuf Historical Society, Box 622, Waterford, PA 16441.

DISCOVER THOUSANDS OF LOCAL HISTORY BOOKS
FEATURING MILLIONS OF VINTAGE IMAGES

Arcadia Publishing, the leading local history publisher in the United States, is committed to making history accessible and meaningful through publishing books that celebrate and preserve the heritage of America's people and places.

Find more books like this at
www.arcadiapublishing.com

Search for your hometown history, your old stomping grounds, and even your favorite sports team.